WATERCOLOR FOR THE *fun* OF IT
Easy Landscapes

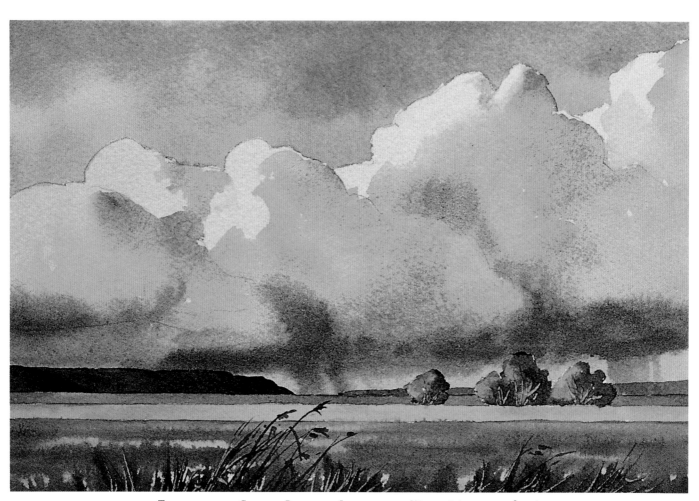

Thunderhead Cloud • Brigitte Schreyer • 7½" × 11" (19cm × 28cm)

WATERCOLOR FOR THE *fun* OF IT

Easy Landscapes

Jack Reid

NORTH LIGHT BOOKS
CINCINNATI, OHIO
www.artistsnetwork.com

751.42
R
14 DAY

About the Author

Jack Reid is a professional watercolor painter and author of two best-selling books: *Watercolor Basics: Let's Get Started* and *Watercolor Basics: Painting Snow and Water*. Canadian by birth, he has had many honors, one of which was becoming an elected life member of the Canadian Society of Painters in Watercolors, and he has won many awards in national exhibitions with the society. He has been a full-time painter since 1970. His paintings hang in select art galleries in Canada, as well as in many private and public collections, including H.R.H. Queen Elizabeth. A popular instructor, he has taught more than 15,000 students to paint. Jack conducts domestic and international workshops and resides in Brampton, Ontario, Canada.

Published by North Light Books, an imprint of F+W Publications, Inc., 4700 E. Galbraith Road, Cincinnati, Ohio 45236 (800) 289-0963. First edition.

Other fine North Light Books are available from your local bookstore, art supply store or direct from the publisher.

08 07 06 05 04 5 4 3 2 1

Library of Congress Cataloging-in-Publication Data

Reid, Jack
 Watercolor for the fun of it: easy landscapes/Jack Reid.--1st ed.
 p. cm.
 Includes index.
 ISBN 1-58180-429-6 (pbk. : alk. paper)
 1. Watercolor painting--Technique. 2. Landscape painting--Technique. I. Title: Easy landscapes. II. Title.
ND2240.R45 2004
751.42'2436--dc22

Editor: Bethe Ferguson
Cover and Interior Designer: Wendy Dunning
Production Editor: Christina Xenos
Interior Production Artist: Anna Lubrect
Production Coordinator: Mark Griffin

METRIC CONVERSION CHART

to convert	to	multiply by
Inches	Centimeters	2.54
Centimeters	Inches	0.4
Feet	Centimeters	30.5
Centimeters	Feet	0.03
Yards	Meters	0.9
Meters	Yards	1.1
Sq. Inches	Sq. Centimeters	6.45
Sq. Centimeters	Sq. Inches	0.16
Sq. Feet	Sq. Meters	0.09
Sq. Meters	Sq. Feet	10.8
Sq. Yards	Sq. Meters	0.8
Sq. Meters	Sq. Yards	1.2
Pounds	Kilograms	0.45
Kilograms	Pounds	2.2
Ounces	Grams	28.3
Grams	Ounces	0.035

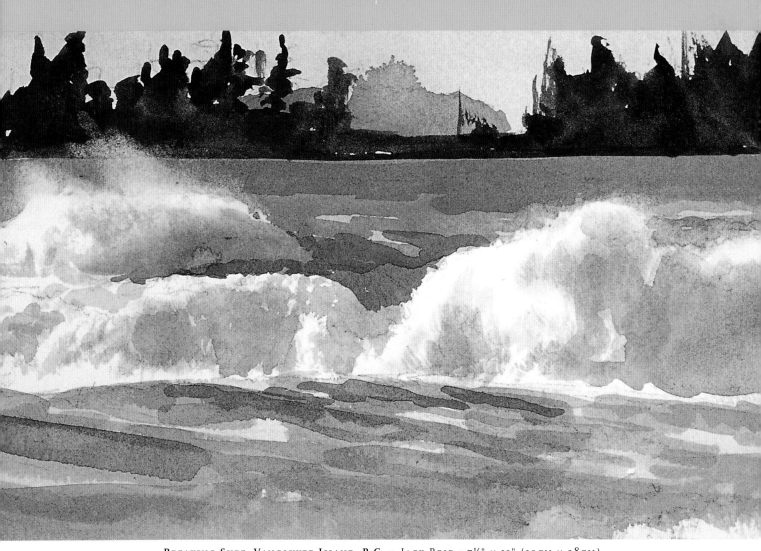

BREAKING SURF, VANCOUVER ISLAND, B.C. • JACK REID • 7½" × 11" (19CM × 28CM)

Dedication
I dedicate this book to the memory of Maggie Reid, my wife, my first and only love,
and my very best friend and supporter without whom I could not have enjoyed a
full and rewarding life. I also dedicate this book to a living and loving God.

Table *of* Contents

1) Water

Learn to paint one of the most popular subjects in watercolor. Capture the energy and power or the melancholy stillness of a tidal pool with five simple step-by-step demonstrations. Use techniques such as glazing, flat washes and graded washes to paint a waterfall over rocks and an ice floe in Alaska.　　**page 18**

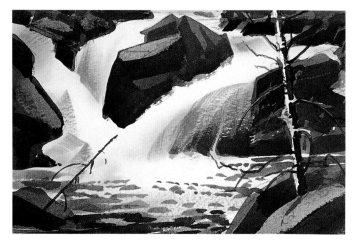

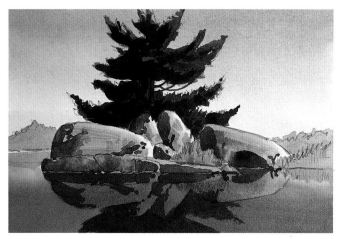

2) Trees

Capture the elegant spirit of trees in your watercolors while avoiding stiff and overly fussy images. In six exercises you'll learn to create the illusion of distance with single-stroke trees, build layers of trees in your painting using positive and negative space and add the realistic texture of trees to your paintings using watercolor.　　**page 30**

3) Mountains & Hills

Learn to create fantastic mountain scenes using a reference photo or your imagination. Paint a mountain in reflection, learning the importance of value, and create a brilliant sunset against a mountainside. You'll see the beauty of a limited palette and learn to paint loose and free.　　**page 46**

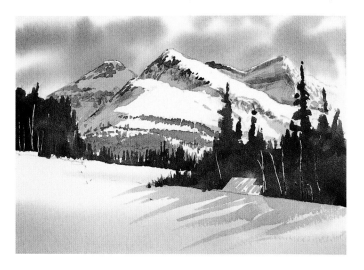

4) Skies

Learn how to recreate the awe-inspiring beauty of clouds and skies in your paintings. Follow along with five step-by-step demos focusing on good use of color and brush techniques. Discover how to paint the sky at various times of day and in varying weather patterns. Add dark and stormy clouds to your paintings or a beautiful sunset reflected on the still waters of a lake.

page 58

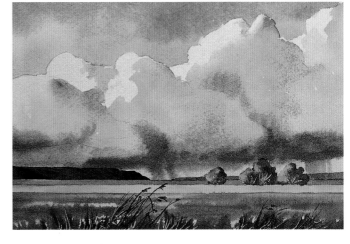

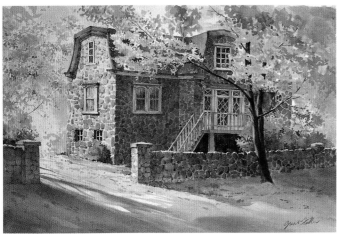

5) Buildings

Man-made structures such as sheds, churches and cabins can be an exciting addition to your watercolor paintings. In this chapter you'll see how to find the best elements in a reference photo or use a combination of elements to design your own landscape. **page 70**

6) Textures

Textures are important visual elements that bring your watercolor paintings to life. Try your hand at painting driftwood on a sandy beach, the sun against a desert landscape, rocks wet with the morning tide and more! **page 84**

Introduction

How would you like to be able to paint wherever you find yourself, whenever the mood strikes? I'm about to teach you how to do just that. Whether you are on vacation in a distant country, hiking in a nearby park or stuck in transit with time to fill, this book will show you how to paint beautiful landscapes comfortably anywhere, anytime. To help you understand what I have planned, close your eyes for a moment and visualize a past trip—a vacation abroad or near home. As you journey back to that time, recall a point where you became disillusioned with your holiday and felt bored, wishing you could do something else, or just escape. Maybe it was pouring rain when you wanted to go for a walk. Or you were touring a city you always wanted to visit and the tour bus broke down. Perhaps you were sitting for what seemed like eternity in an airplane or airport waiting for a delayed flight. Or perhaps your room was not ready when you arrived at your hotel and you had to sit in the lobby bored and irritated. I am sure you can think of many times when all was not as you had hoped. I'll show you how to take lemons and turn them into lemonade. You'll learn how to paint comfortably in uncomfortable places by minimizing your equipment into a compact, light, easy-to-carry kit, which can be safely taken aboard aircraft, bus, family vehicle, rail car or any other form of transportation, or carried to any outside place where you feel inspired to paint. You'll also learn how to transform reference photos into beautiful landscapes. This book offers simple ways for you to paint in watercolor no matter where you find yourself in this increasingly stressful and complicated world. In addition to simplifying the equipment, the chapters are broken down into simple subjects that make up all landscapes such as water, trees, mountains, skies, buildings and textures! Follow along with the step-by-step demonstrations and enjoy great results, even if you are a novice. You'll learn how to create a portable painting kit, how to buy and prepare paper, and five basic watercolor painting techniques. Some exercises are simple and require one color only; others are a bit more complicated, requiring the full palette. As a special treat, you'll learn how truly versatile watercolor can be as four artists share their interpretations of the world around them. Let's get started painting landscapes for the fun of it!

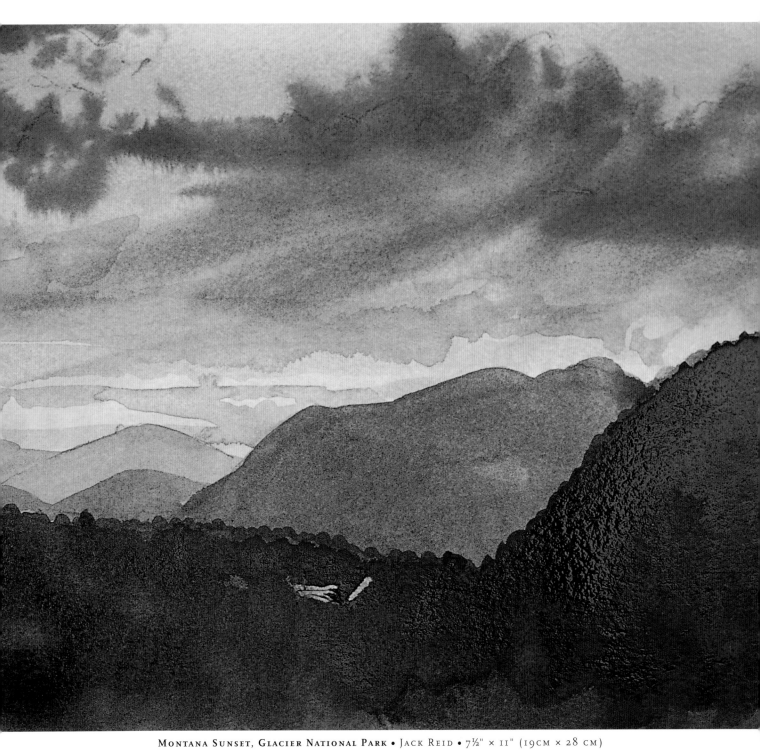

MONTANA SUNSET, GLACIER NATIONAL PARK • JACK REID • 7½" × 11" (19CM × 28 CM)

A Quick Start Guide

GLOSSARY OF TERMS

Composition—A harmonious arrangement of different shapes and colors in a pleasing design.

Coroplast (Gator board)—A polypropylene sheet—like corrugated cardboard—that makes a light, sturdy and waterproof mount.

Dry-on-Wet—A brush wiped nearly dry, loaded with a wash, and then drawn across wet paper to create a more controlled, fluid look.

Drybrush—A brush wiped nearly dry, loaded with a wash, and then drawn across dry paper to create a mottled effect.

Flat Wash—A wash that covers all or part of a painting with the same value of pigment.

Glazing—Painting one wash of transparent pigment over another.

Graded Wash (Gradated Wash)—A wash that gradually fades in value from light to dark or vice versa.

Paper Weight—The number that refers to the thickness of the paper. 300-lb. (640gsm) paper is strong and won't buckle; 140-lb. (300gsm) paper is flimsy and, when wet, becomes difficult to work with.

Scrubbing—A technique in which you lift pigment from a painting with a stiff scrub brush.

Staining—Watercolor paint (pigment) that dyes the paper.

Thirsty Brush—A clean, but damp, brush that has more water in it than paint; when applied next to a color will soak up the pigment into the brush.

Value—The intensity of a given color in degrees of dark to light based on the ratio of pigment to water.

Wet-on-Dry—A painting technique in which a wet, juicy wash is charged on dry paper.

Wet-on-Wet—A painting technique in which a second wash or deeper wash is charged on wet paper. This technique creates a blurred or diffused effect.

Before you begin, I'll cover the materials you need to paint what the French call *"plein air,"* or landscape paintings, outdoors. Some materials are the same for at-home painting, while other supplies are small and compact, making them ideal for painting on the go. You can travel anywhere with this arrangement. Don't cut costs by buying student-quality supplies. You'll never get the results you want if you work with mediocre tools.

Jack Reid's Favorite Paints

You will only need seven pigments to complete my demonstrations. My approach is simple and you can mix a multitude of colors with these seven pigments. I always use and recommend Winsor & Newton artist-quality watercolors. They can be bought in tubes or pans.

- Aureolin Yellow
- Burnt Sienna
- Cobalt Blue
- Raw Sienna
- Rose Madder Genuine
- Ultramarine Blue
- Viridian

Brushes

- ¼-inch (6mm) flat
- ½-inch (13mm) flat
- 1-inch (25mm) flat
- 1 ½-inch (38mm) flat
- 2-inch (51mm) flat
- No. 2 round
- No. 6 round
- No. 10 round
- No. 14 round
- No. 16 mop quill (or a no. 18 round)
- No. 4 script liner(also called a rigger)
- Hog hair bristle brush (cut short on an angle for scrubbing)

Palettes

The Cotman mini palette is ideal when you don't have a lot of space to spread out your supplies. If the palette contains student-grade pans, replace them with artist-quality pans. You will need a set of brushes as well; the small sable brush is simply not enough for serious painting. The Holbein field box shown at right is larger but still convenient palette for painting small studies outdoors.

You can also buy a white palette from any art or craft store. It should have a large mixing area and at least ten wells.

Paper

I recommend 300-lb. (640gsm) rough watercolor paper. The extra weight makes the paper

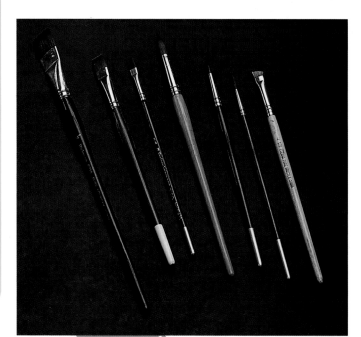

Brushes

These are the brushes I use for outdoor painting, beginning on the left: 1-inch (25mm) flat, ½-inch (13mm) flat, ¼-inch (6mm) flat; no. 10 round, no. 6 round, and no. 4 script liner, as well as a short bristle hog hair brush cut short on an angle for scrubbing.

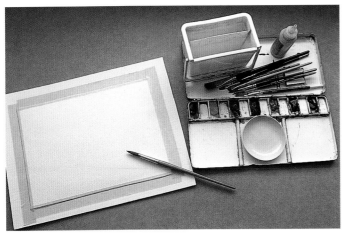

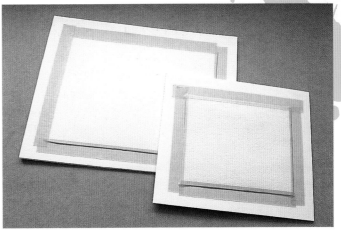

Essential Supplies

Here are the essential supplies you need for painting away from home: a Soya dish for mixing washes, plastic water bottle, a plastic water bowl to clean your brushes in, compact palette (Holbein shown) with artist-quality watercolor pigments, artist-quality brushes, white Coroplast, and 300-lb. (640gsm) rough paper.

Prepare Your Paper

Tape a piece of paper to each side of a Coroplast sheet. When you complete one painting, simply cover with a sheet of newsprint, flip the Coroplast over and begin the next.

thicker than 140-lb. (300gsm) paper and will ensure the best possible results. Cut each full sheet into sixteen 5" × 7" (13cm × 18cm) pieces or eight 7" × 11" (18cm × 28cm) pieces.

You can also buy individual sheets of 140-lb. (300gsm) paper or watercolor blocks. Blocks are more expensive than full sheets of 300-lb. (640gsm) paper and will buckle when wet. If you use 140-lb. (300gsm) paper, stretch or tape it down to avoid warping and buckling. You will also need to gently sponge

off the sizing (a gelatin-like substance that controls the absorbency of paint) before you begin to paint.

Miscellaneous Materials

- Paper tissues for blotting pigment
- White Coroplast, Plexiglas or drying board
- Masking tape for taping paper to Coroplast and isolating mistakes to be scrubbed

- 2B pencil for sketching
- Kneaded eraser
- Sketchpad
- Utility knife for scoring and scraping
- Backpack or other compact case to carry supplies
- Soya dish
- Plastic water bottle and bowl

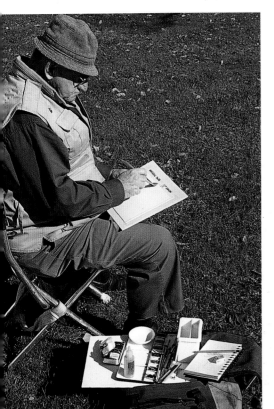

Materials and Tips for Painting Outdoors

Painting outdoors can be a rewarding and wonderful endeavor. Make the most out of your experience by preparing your materials in advance.

A folding aluminum stool with telescopic legs, which can be heightened or lowered, turns any place into a comfortable painting space. Select one that is light and has storage pouches under the seat. If you do not have a stool, don't worry. You can always use a park bench, airline seat with fold-down tray, bus or railcar seat, or chair in your hotel room. When painting away from home, use your imagination. Necessity is the mother of invention.

There are many ways to transport your equipment, but I like to use a backpack to carry my supplies. It's a good idea to line the inside of your backpack to prevent materials from getting crushed. You can also use your backpack as a table to hold your supplies as you paint.

This is the best way to paint en plein air. In my left hand, I am holding the Cotman field box and a couple of brushes. With my knee, I am supporting the paper mounted on coroplast. This leaves my right hand free to paint.

Set the Scene With Reference Photographs

There is nothing like painting a picture on site. You can really take in the scene. You feel the surroundings—the wind, the temperature. You smell the scents. You hear the water rushing, the wind rustling leaves, the birds singing. It's quite an experience—one you will remember for a long time. It will become etched in your mind.

Painting on location is not always possible, though. You may be in a hurry to get somewhere. You may have a plane to catch.

The weather may not be cooperative. Because of a whole host of reasons, I always carry a camera on my travels. And I recommend you do this as well. A camera will allow you to collect images you can refer to when you do have the luxury and time to paint a picture.

A camera, then, is a useful tool for watercolor painting. I have included two photographs and the finished painting from exercises in this book. Sometimes, you will

note, I have painted almost exactly what is in the photograph. In others, I have crafted my own picture, retaining the elements I like with ideas from other pictures and even my imagination. I may add a tree, a seagull, rocks or a different sky. That's the beauty of watercolor painting: You can make up whatever you want. The key is to add to the design, not take away.

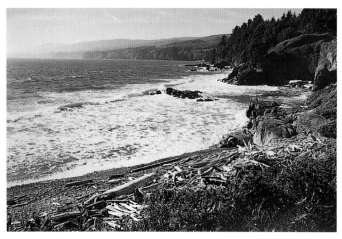

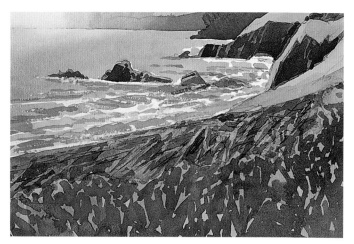

Dare to Compare
The painting of *Point, No Point* in chapter one is quite close to the original photograph. You will notice I made the surf more interesting and the foreground more colorful.

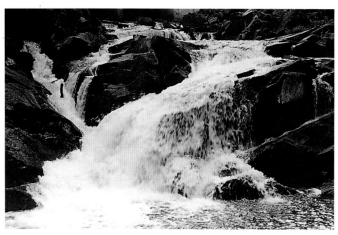

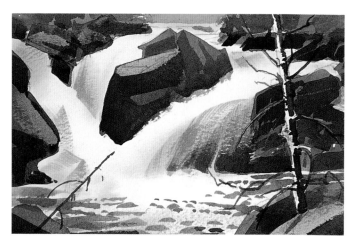

Alter Your Photos to Add Interest
In *Waterfall at Wakefield Hill Province of Quebec* I added trees that were not in the original photograph. Although I like the original photograph, I thought the trees would make it much more interesting.

Unlock the Secret of Values

Value is an important concept to learn. Simply put, it's the strength or intensity of a color. The higher the value, the more intense the color. You can reduce the value of a color by adding more water. Add more pigment to increase the value.

A finished painting works not so much because of the colors you painted, but because of the values of each color painted.

The value of a color is more important than the actual color. By controlling the value, you control contrast and depth, which gives the finished painting perspective.

I have shown a value scale (below) with four intensities of color. It doesn't matter how many value levels a scale has; it merely illustrates the idea that every color has a range of values from light to dark.

The concept of value will become more clear as you progress through the demonstrations in this book. You can also get a jump start by painting one on your own using the value scale as a reference. Remember to take your time and make sure there is an even progression between each of the values on the scale.

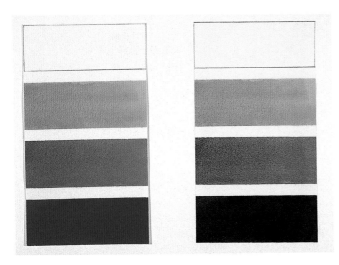

Value Scales

The word *value* is best explained through pictures. The chart on this page is a value scale from one to four in Ultramarine Blue and in black and white. Notice in the Ultramarine Blue scale how it begins with white and then deepens in intensity. White is a value. Every scale for any color begins with white, or no pigment, on the light end and deepens until it is 90 percent pigment and 10 percent water.

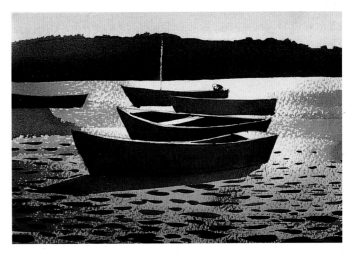

Quick Value Study

I painted *Fishing Boats at Rest Late Afternoon* in color and then photocopied it in black and white to show how value makes the painting work. Notice where the value is dark and where it is light. Notice how the contrast is more important than the actual colors used. I suggest, at least to start, that you photocopy your finished paintings in black and white and note how the values you used worked and how they didn't work. If your painting does not have the punch you were trying to achieve, it is probably because of values, not color.

Discover Basic Watercolor Techniques

Everything I have ever painted in watercolor has been based on the mastery of four basic techniques: flat wash, graded wash, dry-brush and wet-on-wet. Once you learn these techniques you will be able to paint anything you can imagine. The only way I know to master the techniques is to practice. In this chapter you will practice them by painting actual paintings.

Four Essential Techniques

Here are samples of four techniques, starting in the top left corner and moving clockwise. They are flat wash, graded wash, wet-on-wet and dry-brush.

A flat wash covers all or part of a painting with the same value of pigment. This is used when you want to paint an entire area the same value, such as a sky. A graded or gradated wash gradually fades in value from light to dark. It is used to paint cylindrical objects in strong light. For wet-on-wet technique, you moisten paper with either clear water or a first wash. Then charge it with a second wash or deeper wash while the first is still wet to create a blurred or diffused effect. For dry-brush, you load a brush with a wash, wipe it near dry, and then drag it across rough paper to create a mottled effect. Use dry-brush when you want to create the illusion of sparkle on water or texture on tree trunks.

Wet-on-Dry Wash

This is a twist on the wet-on-wet technique and a favorite of some of the contributors. In this stroke you'll use a fully loaded brush on dry paper. Your edges will be more defined than with the wet-on-wet technique.

Coastal Scene

By Jack Reid

This exercise will combine four techniques: flat wash, graded wash, wet-on-wet and dry-brush. As you paint this picture and others in this book, pay close attention to the value of each wash—the intensity of the color. I'm not setting down any rules; I'm simply sharing my theories. And to me, value is more important than color. Value, not the colors themselves, creates the mood.

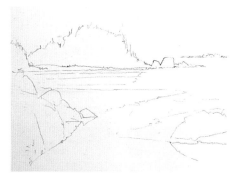

1 | Sketch It Out
Sketch the island, tidal pools, beach and rocks.

[MATERIALS LIST]
- Burnt Sienna
- Cobalt Blue
- Raw Sienna
- Ultramarine Blue
- Viridian
- ½-inch (13mm) and 1-inch (25mm) flats
- Nos. 4, 6, 8 and 10 rounds
- 300-lb. (640gsm) rough watercolor paper
- Miscellaneous materials from page 11

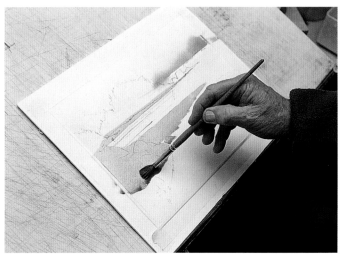

2 | Wash in the Sky, Distant Headland, Sand and Rocks
Mix a light-value blue-gray wash with Cobalt Blue and Burnt Sienna. With a 1-inch (25mm) flat, paint a graded wash for the sky from clear to dark, ending with a darker wash at the waterline. Remember to always angle your paper on a 15-degree angle when painting graded washes.

Deepen the value of the blue-gray wash. With a ¼-inch (6mm) flat brush, and using wet-on-wet technique, paint a distant headline. Brush the wash along the waterline, overlapping the previous stroke slightly, and then turn the paper over and allow to run into the sky. Let dry.

Mix a sand-colored wash with Cobalt Blue, Burnt Sienna and Raw Sienna. With a no. 10 round, paint exposed strips of sand in a flat wash, as well as the rocks and beach in the foreground.

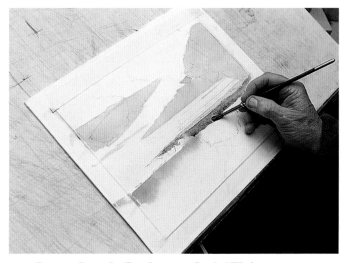

3 | Begin to Paint the Tree Line in a Graded Wash
Mix Ultramarine Blue, Burnt Sienna and Viridian into a dull, blue-green wash. Turn upside down and, with a no. 8 round, paint a graded wash along the edge of the sand.

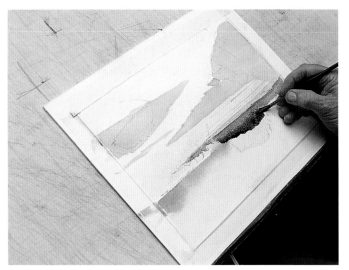

4 Complete the Tree Line
Deepen the blue-gray wash as you paint the tree line.

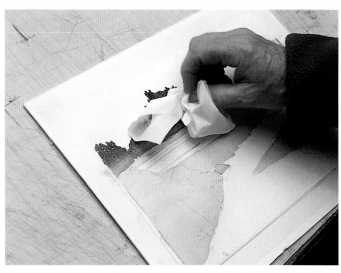

5 Create a Misty Effect
When finished, take a tissue and lightly lift out pigment to create a misty effect.

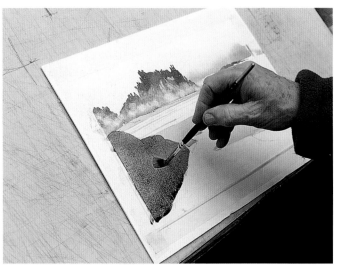

6 Paint Rocks With Flat Wash and Highlight With Wet-on-Wet
Mix a dark-value brown wash with Ultramarine Blue and Burnt Sienna. With a flat wash, paint middle distant rocks to the right side of the headland and rocks in the foreground. While still wet, drop in Raw Sienna to indicate highlights in the rock formation. Lighten the brown wash and paint seaweed along the shoreline.

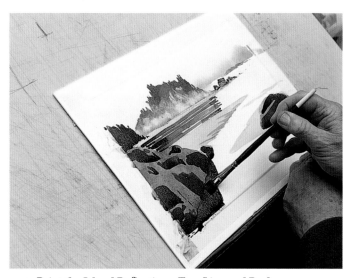

7 Paint the Island Reflections, Tree Line and Rocks
Mix a dark-value green wash using Ultramarine Blue, Burnt Sienna and Raw Sienna and, with a no. 6 round, paint the reflection of the island, leaving strips of exposed sand.

Paint the distance tree line on the left. Add Burnt Sienna to the wash and paint shadows on rocks.

Add Ultramarine Blue and paint water reflections of rocks. With a tissue, lightly lift pigment.

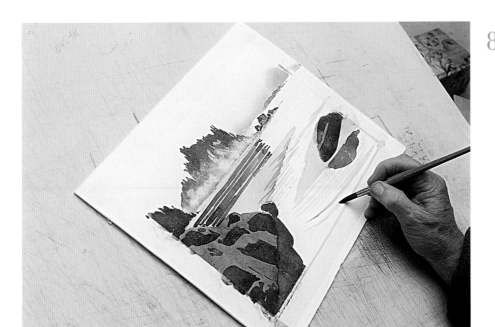

Wash in the Tidal Pools

8 | Mix a light-value gray wash with Cobalt Blue and Burnt Sienna. With a no. 4 round, paint tidal pool patterns on water.

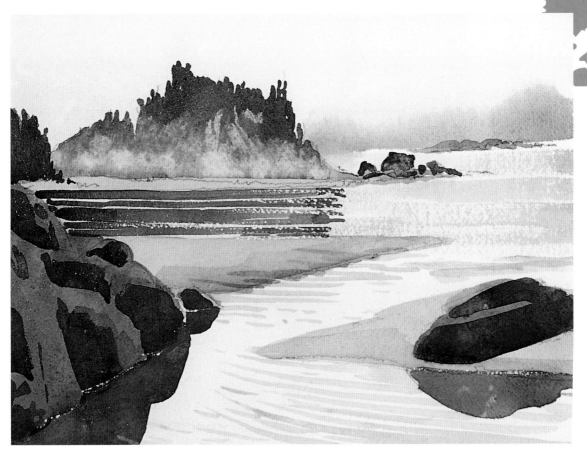

Drybrush the Water

9 | Turn painting upside down. Load ½-inch (13mm) flat brush with the gray wash and wipe off the excess. Hold at a very low angle and drag brush across water from left to right. Detail the sand edge with a flat wash. Allow to dry. To finish, use a utility knife to scratch lines along water's edge to sharpen shadows. Scratch surface of rocks.

WEST COAST • JACK REID • 7" × 11"
(19CM × 28CM)

WATER

Water is one of the most popular subjects when it comes to watercolor paintings. 🌀 **Students** always ask about how to paint crashing surf, still tidal pools or a beautiful waterfall. 🌀 In this chapter I cover these water subjects and more. 🌀 I love painting water in watercolor; the two go hand in hand.

Breaking Surf
by Jack Reid

When you paint this scene, keep in mind that the final painting works not because of the details, but because of the impressions themselves. Specifically, pay attention to how you paint the water and the breakers—put more emphasis on the latter and you will build the strength that this painting needs to be successful.

[MATERIALS LIST]
- 🌀 Aureolin Yellow
- 🌀 Burnt Sienna
- 🌀 Cobalt Blue
- 🌀 Rose Madder Genuine
- 🌀 Ultramarine Blue
- 🌀 Viridian
- 🌀 ½-inch (13mm) flat
- 🌀 No. 12 round
- 🌀 300-lb. (640gsm) rough watercolor paper
- 🌀 Miscellaneous materials from page 11

Reference Photo
You'll notice that the finished painting is quite different from this snapshot. I thought the original was boring, so I redesigned it to make it more fun and interesting to paint. Feel free to add or subtract any of the elements as you see fit when you compose a painting.

1 | **Sketch It Out**
Sketch in the rough details of ocean, rocks and coastline.

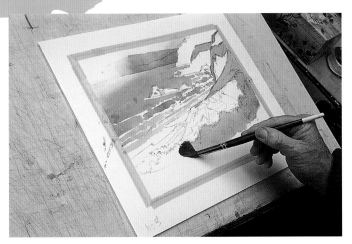

2 | Paint the Water and Shoreline

With a no. 12 round, brush the left corner with clear water. Create a medium-value mixture of Cobalt Blue and grade the wash as you paint around the rocks, leaving strips of white for surf. Allow to dry. Tip the picture on its side and paint the distant headland in a graded wash using the same brush and color. Make a bright yellow-green wash with Aureolin Yellow and Rose Madder Genuine, tinted slightly with Viridian. With a no. 12 round and the yellow-green mix, paint the grass with a flat wash. Allow to dry.

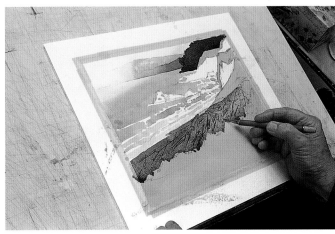

3 | Add the Headland and Beach

Mix Ultramarine Blue and Cobalt Blue; then paint graded washes over the distant headland using a no. 12 round. Allow to dry. Create a dark green mix from Ultramarine Blue, Cobalt Blue and Viridian; then paint a flat wash for the distant trees. Using a no. 12 round, wash on the foreground beach with a medium-dark Burnt Sienna. While still wet, score the beach with a utility knife to indicate logs. Allow to dry.

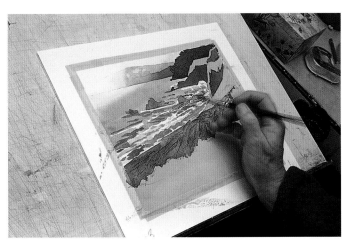

4 | Build the Rocks and Cliffs

With a no. 12 round and the medium-dark Burnt Sienna, paint the offshore rocks and along the cliffs. Allow to dry.

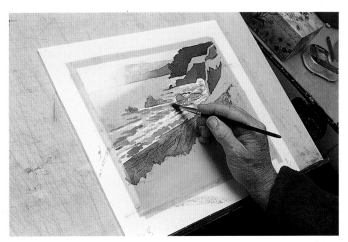

5 | Define the Breakers

Define the breakers with a mix of Cobalt Blue and Viridian using a ½-inch (13mm) flat.

6 **Detail the Rocks and Logs and Glaze the Foreground**

Mix a dark brown wash with Ultramarine Blue and Burnt Sienna. With a ½-inch (13mm) flat, glaze shapes on the rocks and peninsula. Leave highlights on the beach to suggest logs.

Using a no. 12 round and a dark mix of Burnt Sienna and Viridian, glaze over the foreground grass to indicate growth. Again, leave highlights to give depth and texture.

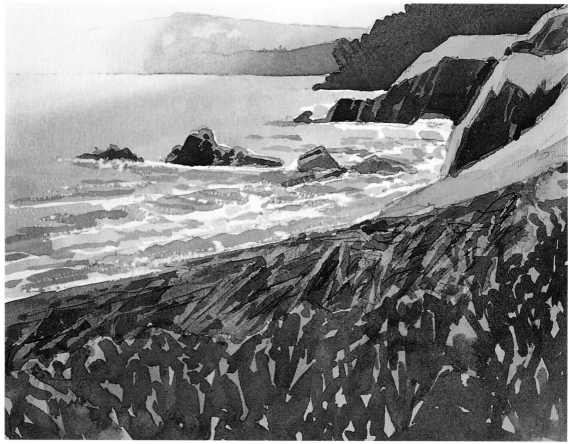

7 **Finishing Touches**

With a medium-value Burnt Sienna wash, glaze over the shoreline fields and foreground to warm the picture. Scrape highlights along edges of rocks at water's edge to indicate surf using a utility knife.

POINT, NO POINT • JACK REID • 7½" × 11" (19CM × 28CM)

Tidal Pools and Reflections

By Jack Reid

This painting is predominantly completed with graded washes. For the most part, I have followed the photograph, retaining the overcast, melancholy mood. Notice how I changed the distant tree line and added a shed to indicate human life. You can take it or leave it, depending on how you feel.

[MATERIALS LIST]

- ⑥ Burnt Sienna
- ⑥ Cobalt Blue
- ⑥ Raw Sienna
- ⑥ Ultramarine Blue
- ⑥ Viridian
- ⑥ ½-inch (13mm) and 1-inch (25mm) flats
- ⑥ No. 12 round
- ⑥ 300-lb. (640gsm) rough watercolor paper
- ⑥ Miscellaneous materials from page 11

Reference Photo
This photo provides a great opportunity to practice reflections. Study how the water reflects the sky and other objects before you proceed.

1 Sketch It Out
Lightly sketch in the shoreline and foreground rocks.

2 Paint the Sky Wet-on-Wet and Add Sand
Wet the entire paper with clear water. Mix Cobalt Blue and Burnt Sienna for a medium gray wash. Drop the gray wash into the sky with the 1-inch (25mm) flat. Add Burnt Sienna to make a reddish brown wash and paint the sand and rocks in foreground.

21

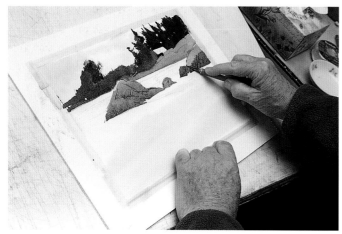

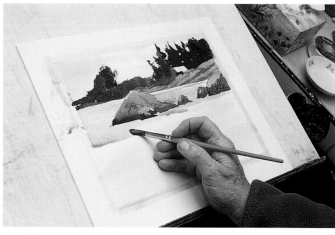

3 | **Paint the Rocks, Tree Line and Tidal Pool**
Deepen the wash with Burnt Sienna and flat wash the background rocks. Mix a dark gray-green wash with Burnt Sienna, Raw Sienna and Ultramarine Blue. With a ½-inch (13mm) flat, paint in the spruce trees. Allow to dry.

Tint the wash with Burnt Sienna, and paint the beach in front of the tree line and the rock in the tidal pool. While the wash is still wet, drop Burnt Sienna and Raw Sienna on the rocks and let it run. Score the rock in the tidal pool with a utility knife.

4 | **Paint the Rocks and Sand**
Mix a dark brown wash with Ultramarine Blue and Burnt Sienna. With a ½-inch (13mm) flat brush, paint wet-on-wet along the bottom of the rocks. This gives the rocks an impression of being grounded. Brush the distant rocks and sand below the tree line to indicate shadows. With a no. 12 round, paint the water with a light blue-gray wash of Cobalt Blue and Burnt Sienna. You'll be painting wet-on-wet tree reflections in the water in the next step, so move quickly.

5 | **Paint Background Tree Reflections**
While the water wash is still wet, paint the tree reflections wet-on-wet using a dark value wash of Viridian, Burnt Sienna and Ultramarine Blue.

Paint the Trees and Rock Reflections

6 Mix a dark green wash with Burnt Sienna, Ultramarine Blue and Viridian and, using wet-on-wet, paint the distant tree and rock reflections. Allow to dry.

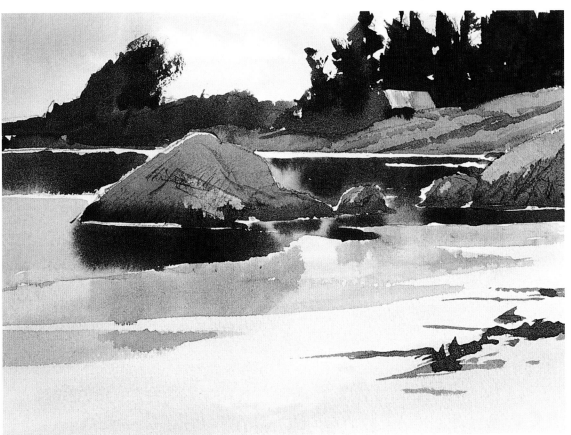

TIDAL POOL
REFLECTIONS •
JACK REID •
7½" × 11"
(19CM × 28CM)

Finishing Touches

7 Mix a light wash of Cobalt Blue and Burnt Sienna; then brush in the semi-wet sand in front of the foreground rocks using the ½-inch (13mm) flat. Once the paper becomes moist, not wet, darken the Cobalt Blue/Burnt Sienna mixture with more pigment and paint the reflections of the foreground rocks. Use ½-inch (13mm) flat. With thick Burnt Sienna and a little water, drybrush the rusty corrugated roof of the distant building using the Use ½-inch (13mm) flat. Add some interest and echo the colors of the trees with seaweed on the beach—use a gray-green wash with Ultramarine Blue and Burnt Sienna. Finish it off by dropping in a mixture of Viridian and Burnt Sienna on the seaweed.

Breaking Waves Close to Shore

By Jack Reid

Breaking waves are a popular subject among painters. There's something about capturing the pounding surf with soft watercolors. This painting is an exercise in glazing with the three primary colors—Rose Madder Genuine, Cobalt Blue and Aureolin Yellow. These glowing colors are perfect for painting surf and foam.

[MATERIALS LIST]

- Aureolin
- Burnt Sienna
- Cobalt Blue
- Raw Sienna
- Rose Madder Genuine
- Ultramarine Blue
- Viridian
- ½-inch (13mm) and 1-inch (25mm) flats
- No. 12 round
- Hog hair bristle brush
- 300-lb. (640gsm) rough watercolor paper
- Miscellaneous materials from page 11

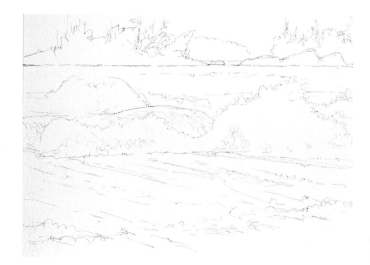

1 | Sketch It Out
Sketch a distant island and the breaking wave.

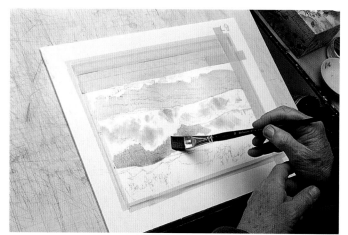

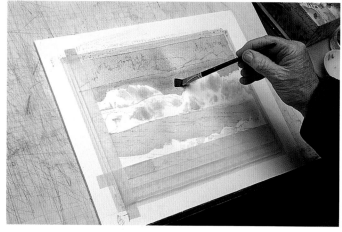

2 | Paint Soft Shadows on Breaking Waves
Wet the entire paper with clear water. Mix a light blue-gray wash from equal parts Rose Madder Genuine, Cobalt Blue and Aureolin Yellow. Using a wet-on-wet wash and ½-inch (13mm) flat, add the main wave—be sure to keep it soft. With the same wash, isolate the wave by painting along the bottom of it.

Deepen the value of the wash. Turn the paper upside down and, with a 1-inch (25mm) flat, flat wash along the edge of the wave to the bottom of the paper.

3 | Define the Waves
Turn right side up. With a ½-inch (13mm) flat, paint a medium-value Viridian wash between the island and the wave. This will isolate the white portions of the wave. Allow to dry.

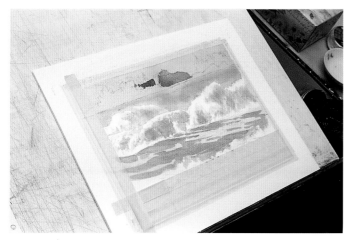

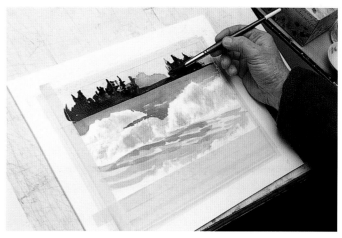

4 **Paint the Headland and Glaze the Waves**

Mix a deep value purple-gray wash from equal portions of Rose Madder Genuine, Cobalt Blue and Aureolin Yellow. Paint the distant headland in a flat wash. Glaze over gray parts of wave with the same wash.

Mix Cobalt Blue and Viridian into a medium-value sea-green wash. Paint patches of water before the wave to indicate the flow of water.

5 **Deepen the Value of the Wave and Paint the Roll**

Deepen the value of the water between the wave and distant headland with a medium-value blue glaze mixed from Cobalt Blue, Rose Madder Genuine and a tint of Viridian. Use a no. 12 round. Let dry.

Tint Viridian with Cobalt Blue. Paint the forward roll on the wave and glaze the water in the forefront. Allow to dry. Mix Raw Sienna, Burnt Sienna and Ultramarine Blue and flat wash the distant island and trees using a no. 12 round. Notice how the contrast makes the wave stand out. Allow to dry.

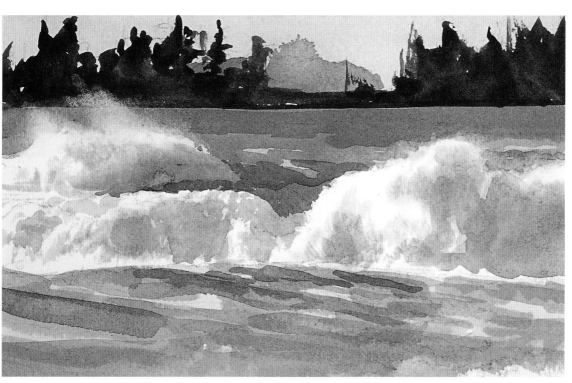

6 **Finishing Touches**

Add more pigment to the Cobalt Blue, Rose Madder Genuine and a tint of Viridian wash. Then deepen the value of the water between the wave and distant headland.

Mix a dark blue-green wash with Rose Madder Genuine, Cobalt Blue and Aureolin Yellow, and glaze the water before the wave. Allow to dry. Brush clean water over the top of the breaking waves. Brush area with hog hair bristle brush and lift with tissue to indicate wave spray.

BREAKING SURF, VANCOUVER ISLAND, B.C. • JACK REID • 7½" × 11" (19CM × 28CM)

Waterfall and Rocks

By Jack Reid

In this painting, I worked from a photograph of a waterfall. Don't be afraid to use your imagination and add elements that don't exist in a scene or reference photo. Notice here how I added a couple of trees to the scene. It adds interest that wasn't there in nature.

[MATERIALS LIST]

- Burnt Sienna
- Cobalt Blue
- Ultramarine Blue
- Viridian
- ½-inch and 1-inch (25mm) flats
- Nos. 6 and 12 rounds
- 300-lb. (640gsm) rough watercolor paper
- Miscellaneous materials from page 11

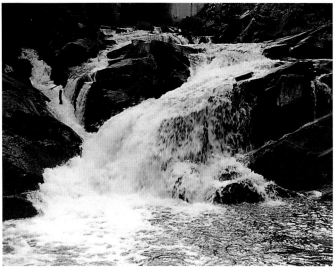

Reference Photo

This photo shows the power of rushing water-fall. Notice how the water bounces off the rocks and ripples at the bottom.

1 | **Sketch It Out**
Sketch in the rocks, waterfall and trees.

2 | **Define the Falling Water**
Wet the entire paper with clear water. Using a light Cobalt Blue wash and a 1-inch (25mm) flat, define the soft shadows on the falling water wet-on-wet. Allow to dry. Add Viridian and dry-brush over each shadow area.

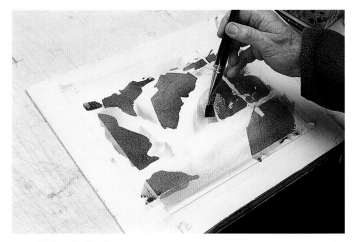 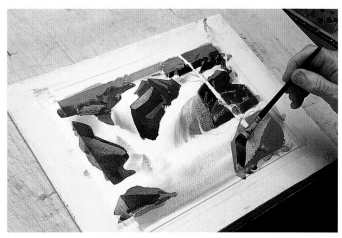

3 | Paint the Rocks

Mix a brown wash using Burnt Sienna and Ultramarine Blue. With a 1-inch (25mm) flat, paint rocks around the waterfall and the tree. With the same wash, drybrush where water is falling to indicate rocks showing through.

4 | Paint the Tree Line and Glaze the Rocks

Mix Viridian, Ultramarine Blue and Burnt Sienna into a dark green wash. Using a no. 12 round, paint a flat wash for the tree line at the top of the picture. Score paper with a utility knife to give texture. Deepen the brown wash used for the rocks by adding Ultramarine Blue. With a ½-inch (13mm) flat, glaze shadows on the rocks. Notice how this pulls together the picture.

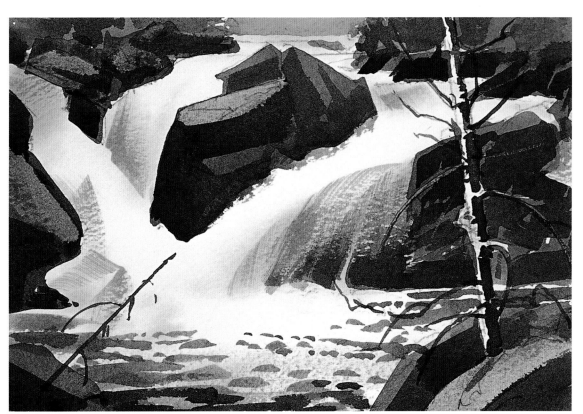

5 | Finishing Touches

With a no. 6 round, paint the right side of the tree. Define branches with the tip of the brush. Score the branches over the water line with a utility knife so they are highlighted.

Add a second, dead cedar tree on the left side. Glaze the tree line and brush reflections on the waterfall. Mix Ultramarine Blue and Burnt Sienna into a dark green wash. With a ½-inch (13mm) flat, glaze the tree line atop the waterfall. Mix Viridian, Burnt Sienna and a hint of Ultramarine Blue and, with a no. 12 round, brush green reflections on the waterfall.

WATERFALL AT WAKEFIELD HILL PROVINCE OF QUEBEC • JACK REID • 7½" × 11" (19CM × 28CM)

Ice Floes in Alaska

By Jack Reid

A painting like this must be done inside rather than on site. Why? Because watercolors freeze. I learned this the hard way when I was about ten years old. I was obsessed with painting watercolors, and I'd go out to paint on freezing winter days. When I would bring them in, they would melt and all the colors would run together.

This particular painting is strong on design and shapes. The key to making it work is to leave just enough white to create a strong contrast. Where have you heard that before! You will practice a series of graded washes primarily of Cobalt Blue with slight tints of Viridian.

[MATERIALS LIST]

- Aureolin Yellow
- Burnt Sienna
- Cobalt Blue
- Ultramarine Blue
- Viridian
- Nos. 6 and 8 rounds
- ½-inch (13mm) flat
- Hog hair bristle brush
- 300-lb. (640gsm) rough watercolor paper
- Miscellaneous materials from page 11

Reference Photo
Original photograph used with permission from Peter Truman.

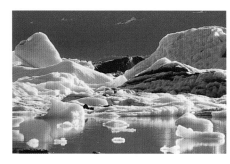

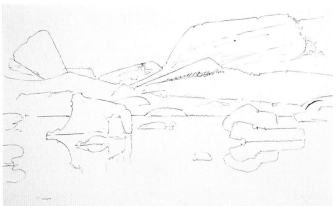

1 Sketch It Out
Sketch the ice floes.

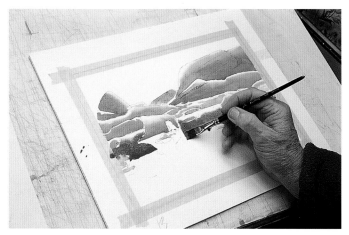

2 Paint the Ice Floes and Reflections
Mix a medium-value Cobalt Blue wash. Paint the ice and snow with a series of graded washes using the no. 8 round. Leave white highlights to indicate sunlit floes. Drop Viridian here and there along the bottom of the floes using the wet-on-wet technique and the no. 8 round. Allow to dry.

Deepen the Cobalt Blue wash with more pigment; then paint the water reflections using graded washes and the ½-inch (13mm) flat. Add tints of Viridian, wet-on-wet, to the reflections.

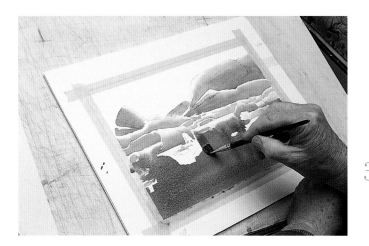

3 Indicate Glare and Highlights on the Rocks
Mix a deep-value wash with Viridian and Ultramarine Blue. Using wet-on-wet technique, brush streaks to indicate glare of the reflection. With the side edge of a utility knife, scrape highlights onto the rocks. Allow to dry.

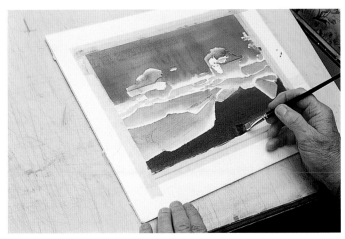

Paint the Base of the Distant Mountain

4 | Turn the picture upside down and paint the background mountain with a flat wash using a dark blue wash made of Ultramarine Blue tinted with Viridian and Burnt Sienna. Notice how this creates a strong contrast with the ice floes.

Define Surface Patterns on the Ice Floes

5 | Mix Burnt Sienna and Ultramarine Blue into a medium brown wash. With a no. 6 round brush, paint dark surface patterns on the floes.

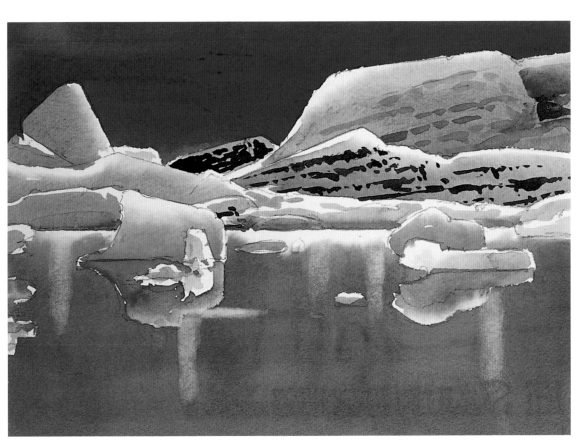

Finishing Touches

6 | Mix a dark blue wash with Ultramarine Blue and Cobalt Blue. With the same brush, paint texture on the sides of the ice floes. Use clear water and a hogs hair bristle brush and remove paint to indicate glare in the water reflections. Lift with a tissue.

ICE FLOES ON ALASKAN PANHANDLE •
JACK REID • 7½" × 11" (19CM × 28CM)

TREES

As you look at landscape paintings, you will quickly notice how differently various artists depict trees.

Trees can be painted in a diverse range of styles, from highly detailed and intricate to loose, simple abstract forms. In fact, trees are one of the best subjects for making your work personal. You may have found, however, that sticking big, solid trees into your otherwise delicate paintings can be a bit intimidating, especially if your previous attempts have produced stiff, overly fussy images that resemble bunches of deep green broccoli, or bright, cherry red and lime green lollipops. Don't despair. You may be surprised to learn that you're on the right track! Your shapes and colors just need a bit of fine tuning. I'd like to show you a few fun tactics that will help you create simple, effective and easy-to-paint trees. Very often people judge a painting by how real it looks—and some artists go through a lot of work to get every little detail in—but the fact remains that most people can't make a real tree. No matter how beautifully you draw and how expertly you apply color, all you can manage to do is make a shape that looks like or represents a tree. The most effective tree symbols incorporate descriptive shape, and to varying degrees color and texture. Rather than focusing on producing botanically correct, precise illustrations, this chapter will show you how to capture the strong, elegant character and spirit of trees while taking advantage of the intrinsic qualities of watercolor.

Think Shapes First
By Linda Kemp

While you might choose to paint every twig and leaf on your trees, all that effort isn't really necessary. Regardless of how tricky your brush-strokes are or how perfect your color selection may be, if your shape is wrong your tree will look like an unidentifiable blob. A good, basic shape is the most effective tool you have when making a tree symbol. Get your shapes right, and the colors and textures will be less critical.

Basic Shapes for Trees
The three basic shapes are the square, the triangle and the circle. Every other shape you can make is a modification or a combination of them. Circles suggest birches, maples, elms, oaks, weeping willows and a variety of other deciduous trees. Squares and triangles suggest pruned hedges, pines, firs and various coniferous trees. Although these shapes are very basic, they are easily identified as trees! Because they are symmetrical however, they appear static and rather boring.

Nature Makes Shapes More Interesting
It's necessary to modify these shapes to make your trees more entertaining and impart a more natural character. Slight changes will make the trees appear windblown, or like they're reaching toward the sun. Stretch, squish, shift and tilt your shapes. Use a variety of different shapes or combine several similar forms. Your landscapes will start to tell a story! Uniformity and even spacing indicates that the trees were planted by humans, whereas dissimilar, random clusters were planted by nature.

Carving Trees

By Linda Kemp

This exercise will help you focus on establishing basic, descriptive tree shapes. The process is a bit unusual because you will begin by laying down a band of color, and then cut away the color to define the tree shapes. This subtractive approach is similar to the technique used by a sculptor who begins with a block of clay, and carves away the excess to release a figure. Rather than painting in your shapes, you'll actually be "unpainting!"

[MATERIALS LIST]

⑥ Cadmium Orange

⑥ Cerulean Blue

⑥ Permanent Rose

⑥ 140-lb. (300gsm) or 300-lb. (640gsm) cold-press Arches paper

⑥ Stiff bristle brushes in a variety of sizes— as used when painting with oils (¼-inch [6mm] and 1-inch [25mm])

⑥ Miscellaneous materials from page 11

1 Prepare the Paper on Plexiglas

Rather than taping or stapling your paper to a board, try this innovative way to prepare your paper. This method will allow you to work for an extended length of time on a wet surface and will eliminate paper buckling. Best of all, it's a fun and exciting way to work!

Generously stroke water over both sides of the paper with a soft, flat brush. Lay the saturated paper on a piece of Plexiglas or other nonporous surface. Use paper towels to mop up excess water that collects around the edges of the paper.

2 Stroke on Color

Pick up a small quantity of Cadmium Orange with the tip of a 1-inch (25mm) stiff bristle brush. Add very little or no water to the paint, as there is already plenty on the surface of the paper. Drag the pigment diagonally across the surface. Don't rinse your brush—just wipe it on a dry towel—and repeat the process with the Cerulean Blue and Permanent Rose. Blend the colors slightly as you work. Apply your paint in a bold, heavy manner. Wimpy paint and delicate washes won't work for this exercise! Don't worry about being messy; it's all part of the learning process.

3 Spatter Freely

With a small bristle brush, spatter the three colors liberally across the color fields and the white areas. Remove the wet painting from the Plexiglas and set it aside on a wooden board to dry. Don't be tempted to use a hair drier to speed the process. Your paper will lie perfectly flat if left to dry naturally. Why not use the time to create more underpaintings?

Carve Out the Tree Trunks

4 | When the underpainting is thoroughly dry, use a small, wet, stiff brush to carve out the trees. Use the basic shapes from page 30 as a guide and keep it simple. Scrub and lift out the color from around and between the trees, blotting with a tissue as you work. The white of the paper will not be completely restored, but there should be enough contrast in value to let the light shine through. Begin with the trunks first. Vary the sizes of the shapes you carve to make some trunks thick or thin and short or tall. Place some close together while others can be more isolated. Small angular lifts will suggest separating limbs and branches.

Establish the Treetops

5 | Carve out the top edge of the trees by scrubbing and lifting color around them. Keep in mind that the top of each tree needs to visually connect with a base. Combine different tree symbols to make an interesting scene. Set the painting aside to dry.

Add a Hint of Sky Color

6 | When dry, tint the lifted areas with a bit of Cerulean Blue or leave the light of the paper. To produce the effect of bright light catching the edges of the tree, allow a rim of white paper, close to your newly carved trees, to remain unglazed.

CARVING TREES • LINDA KEMP • 5½" × 7½" (14CM × 19CM)

Single-Stroke Trees

By Linda Kemp

This project teaches you how to suggest receding rows of trees. It's really quite simple, as you'll be repeating one simple shape made with just one brushstroke. To create the illusion of distance when painting trees, there are a few simple points to remember. Trees that are closest to you will seem larger, warmer in color and more defined, whereas trees in the distance will appear lighter in color and value, smaller and have little detail. Overlapping is also a great device for suggesting the layering of trees.

[MATERIALS LIST]

- Burnt Sienna
- Ultramarine Blue
- Nos. 6, 8 and 10 rounds
- 140-lb. (300gsm) cold-pressed paper
- Miscellaneous materials from page 11

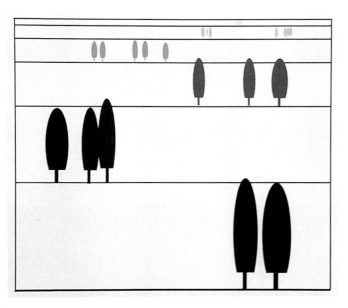

The Illusion of Distance

Imagine that each receding tree sits on a baseline. Notice that as they near the horizon, both the lines and the trees appear closer together. The receding forms become lighter and smaller. In reality, all trees aren't spaced equally. Therefore, to create a more natural appearance, slightly stagger the placement of the trees on the baselines and allow for minor size adjustments within each level.

1 | Prepare a Wet-on-Wet Underpainting and Paint the Rolling Hills

Saturate both sides of your paper with a soft, flat brush and lay the paper on a piece of Plexiglas or other nonporous surface. Wipe away any excess water around the edges. Load either of the wide, flat brushes with juicy Ultramarine Blue. Stroke a broad band diagonally across the upper one-third of the paper.

Without rinsing your brush, mix a quantity of Ultramarine Blue and Burnt Sienna and lay in three diagonal strokes zig-zagging down the paper. Lift and tilt the paper upright to soften the lines and allow the color to flow. Remove the wet underpainting and lay it flat on a wooden board to dry completely.

2 | **The Essential Single-Stroke Tree**
While your underpainting is drying, practice making single-stroke trees on a scrap of paper. Load a no. 6 or 8 round that comes to a good point with any color in your palette. Hold the brush comfortably, almost upright to the paper. Stabilize your hand with your little finger. Touch the pointed tip of the brush to the paper; then press down slowly. The body of the brush should slightly flatten. Make a short, quick drag and lift. The stroke should look like a little teardrop. Fill a page with your practice strokes and reload your brush as necessary. Increase your pace and work quickly. Aim for variety in size, hue, value and spacing. Rough, drybrush marks will suggest natural edges. Your single brushstroke will occasionally leave a little mark at the bottom that hints at a trunk, or you may wish to add a trunk with a thin line and a small brush. Move back to your painting when you are finished.

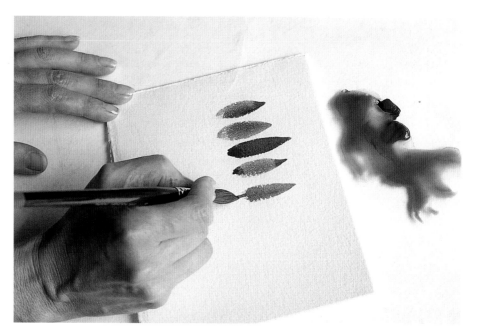

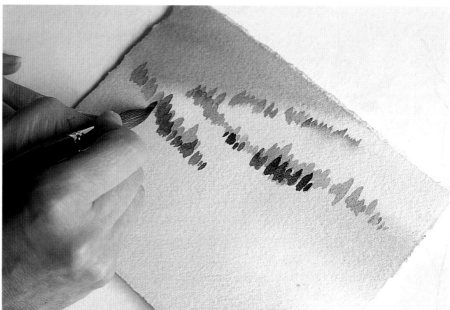

3 | **Paint Distant Trees, Then Move to the Second Row**
When your underpainting is dry, paint a row of single-stroke trees following the natural arc established by the initial washes. Begin near the top with the smallest trees. Use a watery mix of the Ultramarine Blue with just a touch of Burnt Sienna and your no. 8 round. Create the most distant trees using little dashes with the tip of the brush. Be sure to vary the size and spacing. If the marks appear overly dark or dense, blot with a tissue. Soften the base of a few trees with a little clear water.

When dry, paint the second row in the same manner, but use a slightly more neutral, heavier bodied paint. (This is accomplished by using less water when mixing additional Burnt Sienna into the blue.) Make the trees in this row larger and more solid.

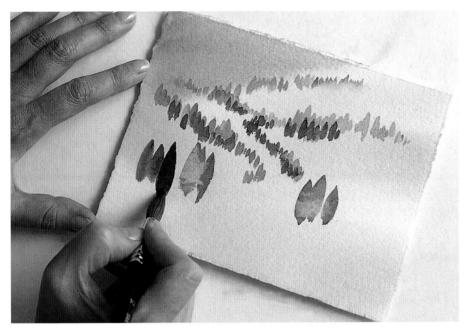

4 **Overlap Layers of Single-Stroke Trees**
Continue to paint the tree rows. As the trees advance from background into the foreground, they should get progressively bigger, darker and warmer in color. Increase the amount of Burnt Sienna while decreasing the Ultramarine Blue. Dry between each layer as you build the overlapping, single-stroke trees. Be sure to include small and large tree forms, adjust the spacing and create clumps as well as solitary trees.

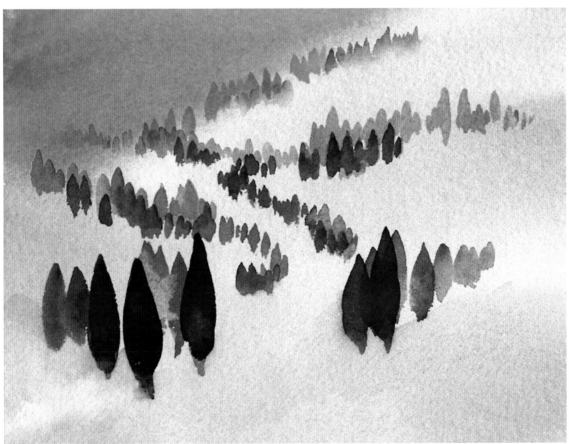

5 **Add the Largest Trees in the Foreground**
Paint the closest trees with a heavy mix of Burnt Sienna and just a little Ultramarine Blue using a no. 10 round brush. Blot with a tissue or drop in additional color to model the forms. While the closest trees are still wet, add a few narrow trunks by pulling color down with a small round brush.

SINGLE-STROKE TREES RECEDING IN THE
DISTANCE • LINDA KEMP • 5½" × 7½"
(14CM × 19CM)

Conifers—Combining Texture and Color

By Linda Kemp

While some painters may aim for simple trees, you may wish to paint more than a flat, basic shape. Introducing color and texture into your trees will help to more clearly define them. Texture, especially when used at the edge of a shape, provides visual clues to the identity and character of an object. One of the exciting—and sometimes frustrating—qualities of watercolor is its fascinating ability to create evocative textures all on its own. Taking advantage of this seemingly unpredictable medium, is just a matter of finding the right balance between paint and water. Remember, just like a trapeze act, timing is everything!

Regardless of whether you want your conifers loose and suggestive, controlled and specifically defined or somewhere in between, the brushwork and application of color is the same. The difference is in the amount of water both on the paper and in the brush.

Critique the Techniques

The tree on the left is painted with juicy pigment on very wet (shiny) paper, which causes the paint to flow rapidly. If your tree becomes an unidentifiable blur, you've used too much water in your paint mixture. This technique works well for soft, suggestive landscapes or distant trees with minimal texture.

The middle tree is done on paper that wasn't shiny, but was still moist, with brushstrokes of thick, fresh paint. The edges are softened, yet the shape remains well controlled. The tree is easily recognized, but the softer impression leaves something to the viewer's imagination.

The final tree is painted with heavy pigment on dry paper using only enough water to allow the paint to spread. This technique offers the most control. As the dry brush skips over the paper surface, it creates the texture of needles or a wispy fringe. Highly descriptive trees like this work well in the foreground or when the goal is a more realistic likeness.

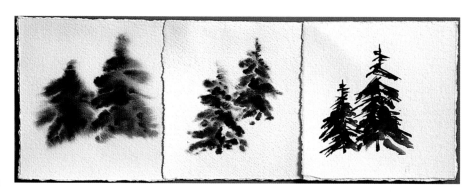

Lay Down the Strokes

For your first few trees, work on dry paper so you can readily check the brushwork. Load a wet, flat brush with freshly squeezed Burnt Sienna, Phthalo Blue and Phthalo Green. Use little water. Fold the color together, but don't overmix. Allow the colors to blend somewhat, but retain their individual hues. Hold the chisel edge of the brush perpendicular to the paper to mark the top spire of the tree. Now begin to add the body of the tree by tapping on the branches from side to side, progressing down toward the base. A single mark may be all that's needed for the shorter branches at the top.

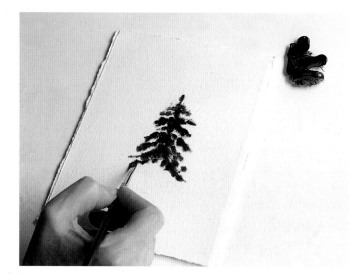

Complete the Body of the Tree

The branches at the bottom will require several choppy, horizontal strokes. Reload the brush with varying amounts of Burnt Sienna, Phthalo Blue and Phthalo Green. Change the angle of the brush as you build. The branches are generally fuller close to the trunk and taper as they extend outward. The tip of the branch may point up or down depending on the variety of tree. Also, try working with the paper upside down to determine which direction is more effective and comfortable for you.

Distant Shoreline of Trees

By Linda Kemp

Watch how a blur of color turns into a mass of distant trees by the addition of just a few specific lines. In this project, color and texture assume the lead. You will be working from wet to dry, taking advantage of the soft, loose forms that occur on wet paper. Then as the paper dries, progress to the formation of more specific shapes.

[MATERIALS LIST]

- Burnt Sienna
- Phthalo Blue
- Phthalo Green
- 1-inch (25mm) or 1½-inch (38mm) flat
- Small bristle brush
- 140-lb. (300gsm) cold-pressed paper
- Miscellaneous materials from page 11

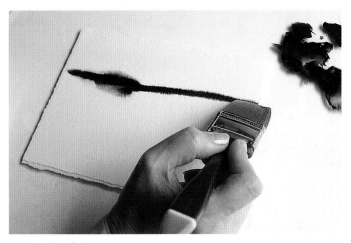

1 | Lay in Colors

Saturate the paper on both sides and place on a piece of Plexiglas. The paper must be shiny. Combine, but don't overblend, Phthalo Blue, Phthalo Green and Burnt Sienna wet-on-wet. With a wide flat brush, touch the color onto the paper and pause for a moment to allow the concentrated color to flow off the tip. Drag the brush straight across the width of the paper.

3 | Add Trees

Allow the paper to dry just until the shine has left the surface. The painting is now extremely vulnerable to scratches and drops of water. Care must be taken, as backruns will occur if the brush and paint are too wet. Load the 1-inch (25mm) flat with heavy dollops of fresh colors. Indicate a few trees with small touches of undiluted color using the chisel edge. The tree will hold its form if the timing is right. If you use too much paint the tree will lose its shape; too little and it will appear stiff. Use the brush handle to scratch a few vertical lines into the moist paper to suggest distant treetops. Remove the damp painting from the Plexiglas and place it on a flat board to dry.

2 | Let the Color Flow

Lift and tilt the paper up and back—not side to side—encouraging the flow of color into the sky and water area. Colors will separate as the staining Phthalos move quickly, yet the Burnt Sienna remains sluggish. If the color will not move, mist lightly with a bit of water. Carefully touch the bottom edge of the paper to a dry towel to absorb excess water. Quickly dry the Plexiglas before replacing the painting.

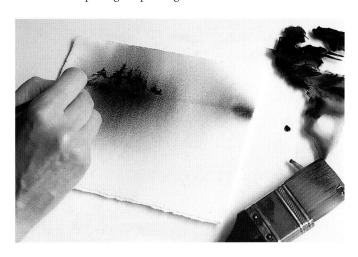

Lift Water Ripples

4 When the painting is dry, lift a few highlights to indicate the surface of the water. Wet a small bristle brush and gently scrub horizontally, lifting a broken line at the water's edge and in two or three places on the water. Blot the lifted streaks with a tissue. Don't overdo it; just hint at the ripples. Just as the rows of trees in the previous exercise appear to get closer together in the distance, space the more distant ripples closer together.

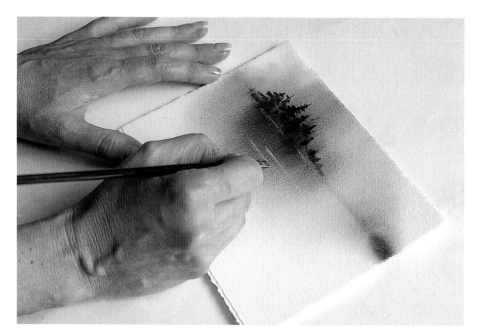

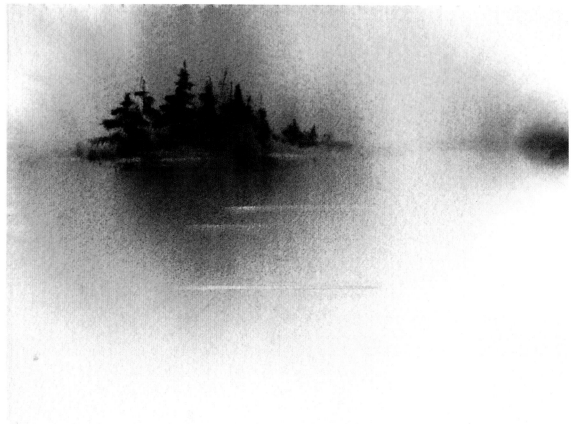

Take a Quiet Moment

5 Stand back and evaluate your finished piece. Adjust the values as necessary. Once you are satisfied, sign your name. Or try repeating this exercise, but change the season by changing the colors. Try Raw Sienna, Permanent Rose and Ultramarine Blue or any other three colors. Remember to fold the colors together rather than thoroughly mix; use less water for greater control.

DISTANT SHORELINE OF TREES • LINDA KEMP • 5½" × 7½" (14CM × 19CM)

Weaving Layers of Trees

By Linda Kemp

Your upright shape is made possible because of your rigid skeleton. In much the same way, without its structural framework, a tree would just be a mound of leaves lying on the ground. It's the bones of a tree—consisting of a complex root system, trunk, limbs, branches and twigs—that determines its shape. To create believable trees, however, you will need to go beyond merely sticking a collection of these parts together. In this exercise you will learn how to approach painting trees from a different direction. I will show you how to build multiple layers of trees by painting the space around them, rather than the trees themselves! This approach is referred to as working in the negative. I hope you will find it intriguing and fun!

[MATERIALS LIST]

- Burnt Sienna
- Ultramarine Blue
- 1½-inch (38mm) flat
- No. 10 round
- 140-lb. (300gsm) cold-pressed paper
- HB pencil
- Miscellaneous materials from page 11

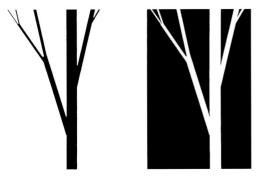

Positive and Negative

On the left is a tree created in the traditional or positive manner. The form has been drawn and then filled in with black. On the right, the space around the tree has been filled in with black, which is negative painting. Working in the negative is a simple shift in the way you see.

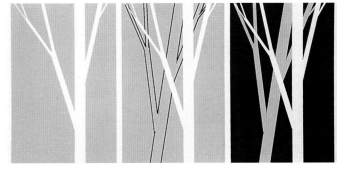

Negative Painting in Three Steps

Before you begin to paint, take a close look at how the process works.
1. Draw and paint around the first tree with a light glaze.
2. Draw the second tree under (behind) the first.
3. Paint around the trees, filling all the negative spaces with a darker color. *Don't try to draw all the layers at the beginning. You'll only confuse yourself.

1 | Complete Wet-on-Wet Underpainting and Sketch the Tree

Saturate both sides of a piece of watercolor paper and place it on your Plexiglas. Using a 1½-inch (38mm) flat, apply vertical strokes of juicy Burnt Sienna and Ultramarine Blue. Spatter and splash the colors to soften the white of the paper and add texture. Transfer to a wooden board to dry.

Sketch the outline of a simple tree. Begin with the trunk and taper the branches upward. Keep your tree basic and flat. Using a no. 10 round, apply a thin glaze of Burnt Sienna mixed with a little Ultramarine Blue around the tree. Begin at the pencil line and pull the glaze outward to the edges of the paper. Don't paint inside the tree. Fill in all the negative shapes with delicate color. Dry the paper thoroughly.

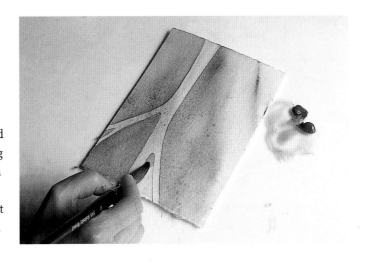

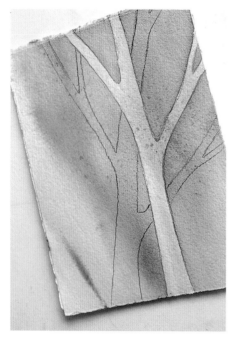

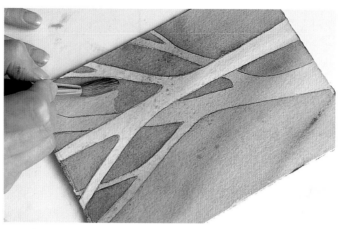

Glaze Around the Trees

3 Fill in the negative spaces that surround the trees with a slightly darker glaze of Burnt Sienna and Ultramarine Blue. Paint from the edges of the trees out. Set the painting aside to dry or use a hair dryer.

Sketch a Second Tree

2 When dry, add a second tree that is tucked under the first. This new tree will be partially covered by the first, so don't draw over your first tree.

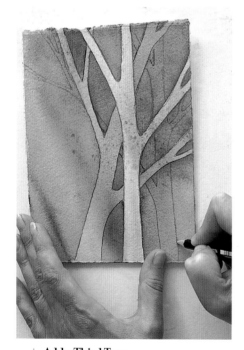

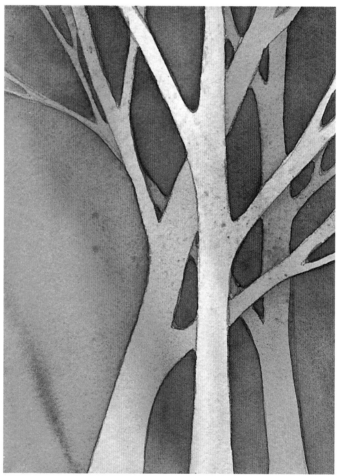

Add a Third Tree

4 Begin a third tree row using the same negative approach. Once again the tree is placed behind the existing two. To make your painting more interesting, be sure to change the widths, lengths, angles and placement as you add new shapes.

Glaze Again

5 Apply the final glaze around the trees with a more concentrated mix of color. Notice that the values increase from light to dark as the layers are built from front to back. To increase the illusion of depth, cool the color with a greater percentage of blue. In this sample I have created three layers of trees. But you don't need to stop now. With more experience, you may find it faster and easier to eliminate pre-sketching the shapes.

WEAVING LAYERS
OF TREES • LINDA
KEMP • 5½" × 7½"
(14CM × 19CM)

Combining Negative and Positive Trees

By Linda Kemp

In this exercise you'll combine the previous negative approach with simple, yet elegant, calligraphic marks to suggest positive trees. It's easy to learn the brush-handling technique, but to become a great tree painter, you'll need to become a tree watcher. It takes time and effort to really see. Study the trees in your neighborhood, photographs and books. Pay close attention to how the trunk rises from the ground and how high it reaches before the limbs split off. As the tree reaches upward, do the angles change when the limbs, branches and twigs subdivide? While each species has common characteristics, no two trees are identical—nature carves each individual form.

[MATERIALS LIST]

⑥ Burnt Sienna

⑥ Phthalo Blue

⑥ 1-inch (25mm) and 1½-inch (38mm) flats

⑥ No. 8 round

⑥ No. 6 script liner (also called a rigger)

⑥ 140-lb. (300gsm) cold-pressed paper

⑥ Miscellaneous materials from page 11

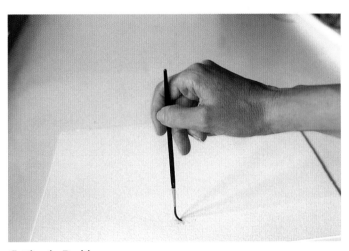

Getting in Position
Roll the hair of a no. 6 script liner in juicy color, and gently hold the brush as you would a pencil. With your opposite hand, grasp the ferrule (shiny metal section) and pull the brush forward, sliding your working hand along until you are holding high on the handle. Turn your working hand so that the brush is perpendicular to the paper. Stand back from the table and slightly extend your arm. This position will allow you to freely work the brush with movements that begin with your shoulder and progress down through your fingertips.

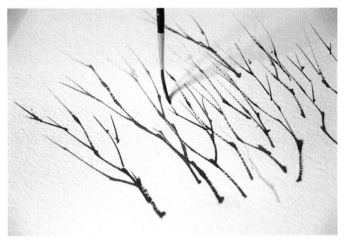

Pushing the Brush
Touch the brush down at the bottom of the paper, and then push away through your arm. (The action should come from the shoulder and elbow.) Push, stop, push, stop. Each time you hesitate, the brush will make a small joint or node. Gradually release the pressure and shorten the intervals as you travel up the paper. When your arm is extended, use your wrist and hand. Finish with a flick of the fingers. Make your first attempts long, straight, but jerky lines. Next try changing directions, zigzagging just slightly each time you pause. Attach new lines that angle out at the heavy nodes to create branches and finally tiny twigs at the outer tips. Practice by filling a page with liner-made trees. Remember to push, stop, push, stop, flick!

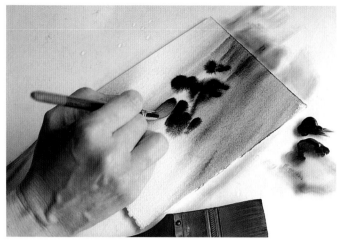

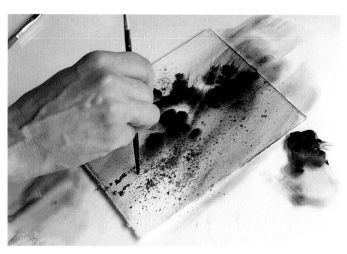

1 | Underpaint With Rich, Dark Colors

Wet both sides of the watercolor paper and place on your Plexiglas. Use both flat and round brushes to sweep a dollop of freshly squeezed Phthalo Blue and Burnt Sienna. You will need a few bold, dark patches. Spatter and splash freely. Lift and tilt the paper to encourage color flow.

2 | Scratch in Branches and Twigs

While the paper is still very wet, use the sharp end of the no. 6 script liner or a pointed stick to scratch in branches using the push, stop, push movement. Keep the branches straight. Don't curve or arc the strokes of your trees, or they will look soft and rubbery. You won't need to use any paint if you drag the tip through dark areas. Allow the painting to dry until the shine leaves the paper.

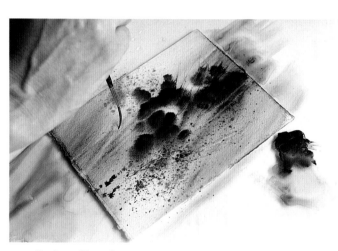

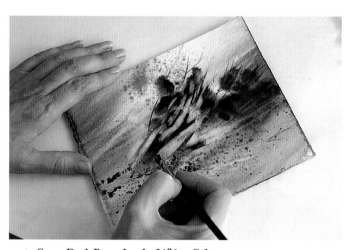

3 | Backrun Branches

Backruns occur in watercolor when wet paint is added to moist paper. Here's a chance to take advantage of this otherwise troublesome phenomenon. When the shine disappears from the paper, but it's still moist, rinse your no. 6 script liner and shake off any excess drips. Repeat the push, stop, push action as you draw the wet brush up through light to mid-value areas of the painting to make negative calligraphy branches. The branches may not appear immediately, as it may take a few moments for the water from the brushstrokes to push the paint away. Set aside to dry.

4 | Carve Dark Branches by Lifting Color

Use a wet stiff brush to lift out the light in the darkest areas of the painting to establish tree limbs and branches. (See the first project in this section.) Scrub gently to clean away some of the dark pigment and blot. Color will lift, but don't expect to get back to the pure white of the paper.

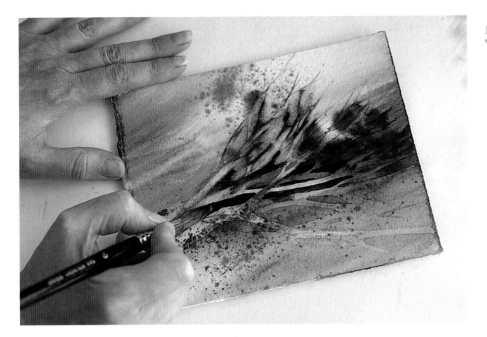

5 | Paint Dark Negatives to Bring Out Lighter Areas

Now glaze dark negative shapes to build more layers of trees, (see pages 39-40). It may help if you draw the trees in pencil first. A single tree may have both light branches that are glazed around with deeper values, as well as dark branches that have been pulled out by lifting. Check to see that the trunks, limbs and branches make sense. Are they wider at the base and become thinner? Can the width of the trunk support the weight of the limbs and branches?

6 | Create Negative and Positive Forms

Work back and forth, creating both negative and positive structures. Add fine twigs to the tips of the branches with your no. 6 script liner. Soften any overly dark areas. When you work to capture the essence of trees, you only need to provide the viewer's eye with a few solid visual clues and then leave the rest to their imaginations.

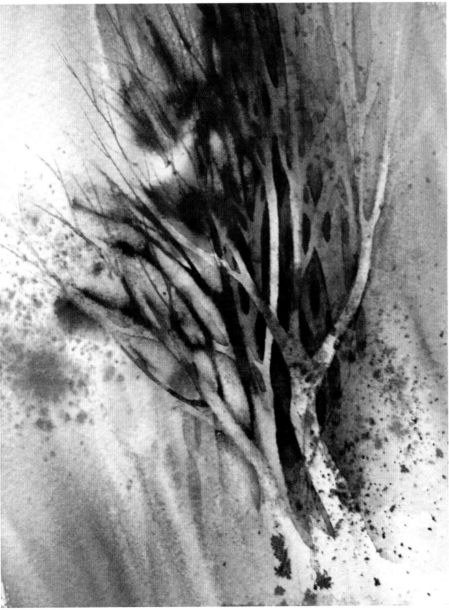

COMBINING NEGATIVE AND POSITIVE TREES • LINDA KEMP • 7½" × 5½" (19CM × 14CM)

Lonely Tree and Rocks

By Jack Reid

This is a very simple, but powerful painting. As you paint it, you may wonder why I used Aureolin Yellow and Rose Madder Genuine instead of straight Burnt Sienna for the orange wash. It's because I felt this painting should have strong light. When you mix Aureolin Yellow and Rose Madder, you get a luminosity and translucency that suits the strong sunlight. Burnt Sienna is flat by comparison. Now, if this scene had an overcast day, the Burnt Sienna would have been perfect.

[MATERIALS LIST]

- Aureolin Yellow
- Burnt Sienna
- Cobalt Blue
- Rose Madder Genuine
- Ultramarine Blue
- Viridian
- 1-inch (25mm) flat
- No. 8 round
- 300-lb. (640gsm) rough watercolor paper
- Miscellaneous materials from page 11

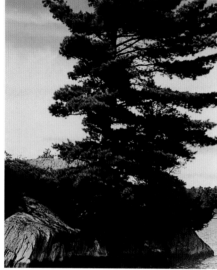

Reference Photo
This photo is a good example of how a simple scene can turn into a dramatic painting.

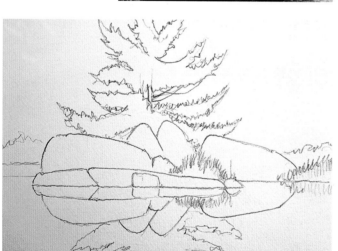

Sketch It Out
1 | Sketch the tree and rocks.

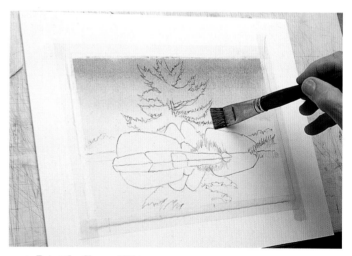

Paint the Sky and Water
2 | Prepare a medium blue wash with Cobalt Blue. Turn the paper upside down, and paint a graded wash for the sky using a 1-inch (25mm) flat. Start out light at the water's edge and deepen the color as you move toward the top of the sky. Turn the paper right side up, and paint another graded wash for the water. Again, the lightest area should be where the sky meets the water. Paint over the tree, but carefully cut around the rocks and water reflection. Allow to dry.

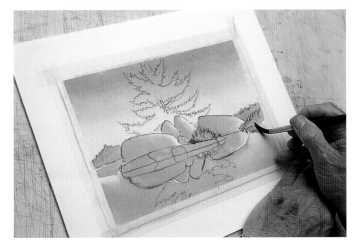

Paint the Rocks With Graded Washes

3 | Mix an orange wash from Aureolin Yellow and Rose Madder Genuine. The light source is hitting the rocks from the right side. With a no. 8 round, paint the rocks with a series of graded washes to accentuate the strong light. Let dry.

Add a tinge of Viridian to the orange wash to create a light green wash. With a no. 8 round, flat wash the clump of grass on the island and to the right of it. Let dry.

Drybrush the Tree and Add the Rocks

4 | Mix Ultramarine Blue, Burnt Sienna and Viridian into a brown-green wash. Turn the paper upside down and drybrush in the tree using the no. 8 round. Turn the paper right side up. Add water to lighten the value of the wash, and then paint the tree's reflection on the water. Let dry.

Mix a light brown wash from Ultramarine Blue and Burnt Sienna. Using flat and graded washes and the no. 8 round, paint the shadows on the rocks and the rock reflections.

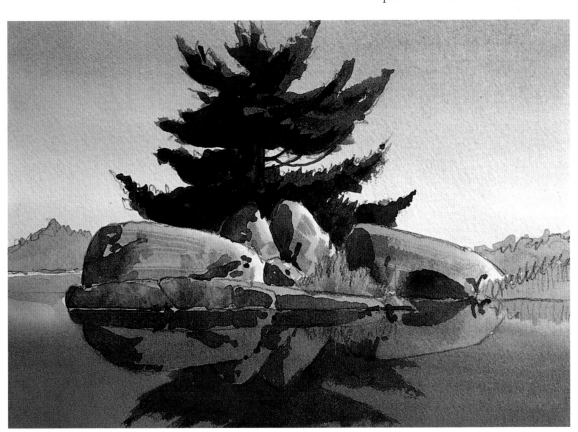

Add the Finishing Touches

5 | Mix a deep green wash with Ultramarine Blue, Viridian and Burnt Sienna and glaze over the shadow areas on the tree using a no. 8 round. Drybrush texture on the rocks. Finally, to complete the picture, mix a deep Cobalt Blue wash and glaze over the entire water area, including the reflections. This will deepen the reflections, which are always darker than the subject.

LONELY TREE AND ROCKS • JACK REID •
7½" × 10" (19CM × 25CM)

MOUNTAINS & HILLS

Mountains are another popular landscape subject. In this chapter, I'll teach you how to paint mountains and the elements you commonly find with them, such as buildings, trees, snow and water. There is nothing like painting a spectacular mountain scene right on location! Of course, this isn't always possible, but you can take a snapshot and paint it at a later time. You can also use your imagination and paint mountain scenes from memory.

Mountains With Exposed Rocks

By Jack Reid

Every painting needs a focal point. As you paint this picture you will find there are several strong elements, but only one is truly the main focus. For any painting to be successful there can be only one main focus. The other elements must work to support the main element, not distract from it. This painting will demonstrate how.

[MATERIALS LIST]

⑥ Burnt Sienna
⑥ Cobalt Blue
⑥ Raw Sienna
⑥ Rose Madder Genuine
⑥ Ultramarine Blue
⑥ Viridian
⑥ ½-inch (13mm) flat
⑥ Nos. 6 and 12 rounds
⑥ 300-lb. (640gsm) rough watercolor paper
⑥ Miscellaneous materials from page 11

1 | **Sketch It Out**
Sketch the rough details of the mountain range and trees.

2 | **Lay the Sky, Mountains and Foreground**
Wet the sky area with clear water. Mix Rose Madder Genuine and Viridian into a soft gray wash. With a no. 12 round brush, paint wet-on-wet leaving white areas. Tip paper and let pigment run. Let dry.

Mix a blue-gray wash with Cobalt Blue and Burnt Sienna. Paint a flat wash on the left side to indicate distant mountains. Paint shadow areas on the middle and right mountains as well.

Wet the foreground below the tree line with clear water. With the same wash and a ½-inch (13mm) flat, paint halfway across the bottom to indicate a graded broad shadow on the foreground snow.

3 Paint the Mountain Tree Line
Mix Ultramarine Blue and Burnt Sienna into a dark gray wash. With a no. 6 round brush, paint the tree line on the mountain with a shaky hand. Go ahead and be a little messy! You don't want your trees to look too perfect.

4 Drybrush the Exposed Rocks on the Mountain
Add Burnt Sienna to deepen the wash. With the corner tip of a ½-inch (13mm) flat, drybrush exposed rocks on the mountains. Add more Burnt Sienna to the wash when you paint the rocks in exposed sun.

5 Paint the Trees and Shadows
Mix a dull green with Burnt Sienna, Ultramarine Blue and Raw Sienna. With a ½-inch (13mm) flat, paint the front tree line. It must be a darker green than the trees on the mountain. As you paint, leave a white space to indicate a cabin in the wilderness. It creates an interesting feature and allows the viewer's eye to fill in the blanks.

Use a utility knife to scrape the impression of birch trees in the forest.

Mix a medium blue Cobalt Blue wash and paint the shadows on mountains, as well as shadows of trees on the snow in the foreground.

Now that you are finished, step back and evaluate your work. What is the star of this painting? Is it the cabin? The trees? Or the mountain?

I say it's the mountains with the cabin and trees as supporting roles. Notice how the zigzag pattern of the trees takes you into the picture with the main focus on the mountains.

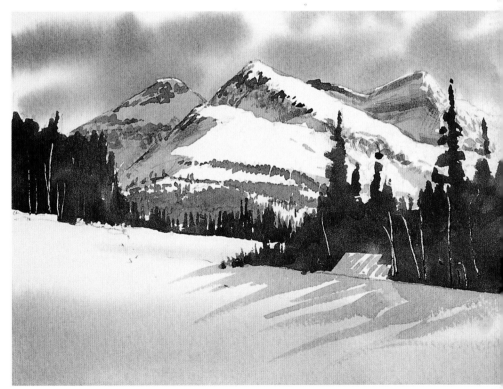

WINTER TWILIGHT • JACK REID • 7½" × 11" (19CM × 28CM)

Mountain River Reflections

By Jack Reid

This is a good exercise in value. Remember when you paint reflections, the value should be slightly darker than the original subject. In this painting, the value of the shadows on the mountain are also important. Glaze over them until you get them just right. The pigments in your limited palette can all be glazed numerous times without turning to a mud brown. The key is to make sure the previous glaze is totally dry before painting the next one.

[MATERIALS LIST]

- Aureolin Yellow
- Burnt Sienna
- Cobalt Blue
- Raw Sienna
- Rose Madder Genuine
- Ultramarine Blue
- Viridian
- ½-inch (13mm) and 1-inch (25mm) flats
- 300-lb. (640gsm) rough watercolor paper
- Miscellaneous materials from page 11

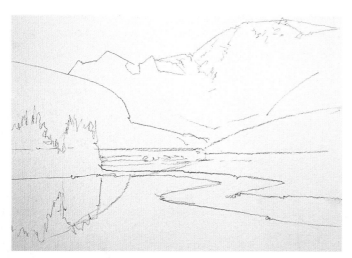

1 | Sketch It Out
Sketch the rough details of the mountain range and trees.

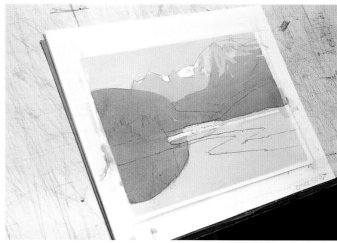

2 | Wash and Glaze the Mountain
Mix a blue-gray wash with Cobalt Blue tinted with Burnt Sienna. With a 1-inch (25mm) flat, flat wash over the entire painting except for patches of snow on the mountains and strips in the foreground. Let dry; then glaze over these areas with the same wash. Let dry again.

Add more Cobalt Blue and Burnt Sienna to deepen the wash. Glaze the mountain on the left and its reflection on the water. Set aside and allow to dry.

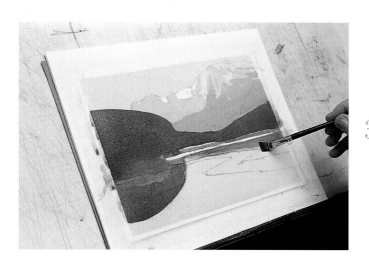

3 | Flat Wash Two Mountains and Paint Mountain Reflections
Add Rose Madder Genuine and Aureolin Yellow to create a deep purple-blue wash. Paint a flat wash over the mountains on the left side and along the bottom of the mountain on the right side to merge the two headlands.

Flat wash the reflection in the water and on both sides of the snow. Grade the wash by brushing clear water with a ½-inch (13mm) flat along the bottom.

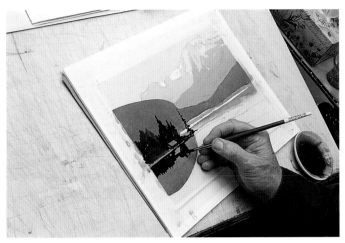

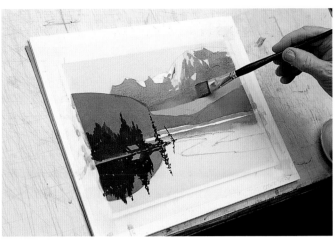

Paint the Tree Line and Its Reflection

4 Mix a rich green wash with Ultramarine Blue, Viridian and Burnt Sienna. Flat wash the tree line on the left side, leaving the impression of a cabin. Leave a slight gap at the water's edge and paint a reverse tree line reflection on the water.

Reglaze the Mountains

5 The shadowed snow on the mountains isn't convincing; it needs to be deepened. This is easy to do. Mix a medium-value wash with Cobalt Blue and Burnt Sienna. With a 1-inch (25mm) flat, paint over the mountains, leaving white for snow patches that are in the sun and light blue for the shaded snow patches. Drybrush the mountain in the foreground, and glaze over the reflected cabin roof.

Add the Finishing Touches

6 Let's add some color with strips of dead grass winding out into the foreground at the base of the mountain. Mix a deep-value dull red-brown with Raw Sienna and Burnt Sienna, tinted with Cobalt Blue.

Add Ultramarine Blue to the wash to make a dark brown wash. Paint dark portions of grass and render a tree. Don't forget to add reflections, too.

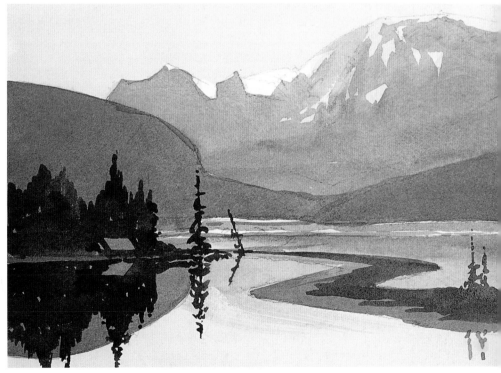

NEAR JASPER, ALBERTA, CANADA • JACK REID • 7½" × 11" (19CM × 28CM)

Foothills and Farm Buildings

By Jack Reid

This painting demonstrates the power of a limited palette: Cobalt Blue, Burnt Sienna, Ultramarine Blue and Rose Madder Genuine. Let's mix it up in this demonstration with negative painting. Remember, negative painting is when you paint dark over light, allowing some light to show through. The dark value emphasizes the contrast and exaggerates the colors, producing a dramatic effect (see chapter two for a more in-depth explanation).

[MATERIALS LIST]

- Burnt Sienna
- Cobalt Blue
- Rose Madder Genuine
- Ultramarine Blue
- ½-inch (13mm) and 1-inch flats
- Nos. 6 and 12 rounds
- 300-lb. (640gsm) rough watercolor paper
- Miscellaneous materials from page 11

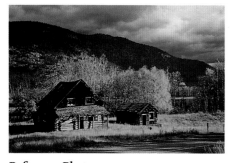

Reference Photo
You'll be simplifying the beautiful autumnal colors against the dark mountain for this demonstration.

Sketch It Out
1 | Sketch the foothills and farm buildings.

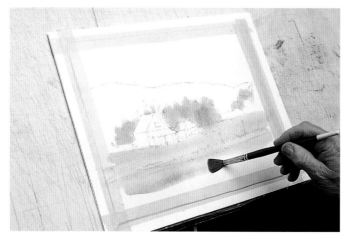

Paint the Trees and Foreground
2 | Wet the entire paper with clean water. Mix Rose Madder Genuine and Burnt Sienna into a medium-value orange. Using a ½-inch (13mm) flat, add the trees with the wet-on-wet technique. Don't make this your life's work! Brush loose, impressionistic strokes quickly.

Add Rose Madder Genuine plus a slight tint of Cobalt Blue to the above mix to create a green-brown wash. With a no. 12 round, brush the foreground area at the bottom of the paper.

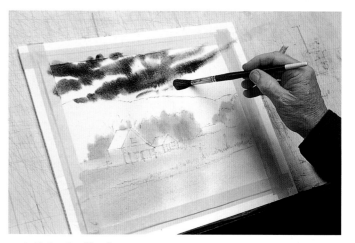

Paint the Clouds
3 | Paint the barn with the green-brown wash from step 2 using the no. 12 round.

Here is where you'll use negative painting to suggest the clouds. Rewet the sky area with clear water. Mix a blue-gray wash with Ultramarine Blue and Burnt Sienna, and then create the clouds wet-on-wet with loose, horizontal strokes into the moistened sky area. Leave some white areas, as these are good for contrast. Allow to dry.

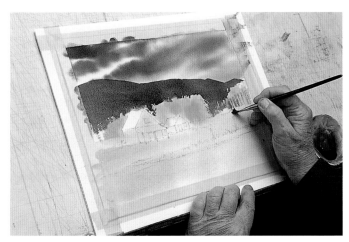

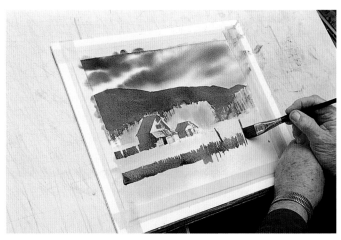

4 | **Paint the Foothills**
Continue using Ultramarine Blue, Burnt Sienna mixture from the previous step, and flat wash in the foothills with the no. 12 round. Paint carefully around the trees. Drybrush over the tree edge with the same color and a ½-inch (13mm) flat.

5 | **Add Details to the Buildings and Trees**
Add more Burnt Sienna to the Ultramarine Blue, Burnt Sienna mix to create a red-brown mixture. With a ½-inch (13mm) flat, paint the shadows on the buildings, as well as doorways and windows. Drybrush the roof to indicate shingles. Deepen the value and flat wash the foreground grass and fence posts using the 1-inch (25mm) flat. With a ½-inch (13mm) flat, drybrush texture on the trees and the foreground. Strengthen the illusion of the foreground grass by scoring with a utility knife while it's still wet.

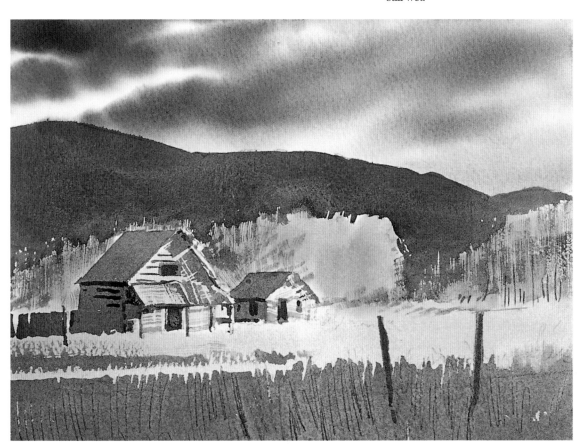

6 | **Complete the Painting**
Finish the painting by mixing a dark gray-brown wash with Ultramarine Blue and Burnt Sienna. Using a no. 6 round, indicate the rough impression of the house logs. Paint an open doorway and window, and strengthen the value of the fence posts.

ROCKY MOUNTAIN BARN AND FOOTHILLS
• JACK REID • 7½" × 11" (19CM × 28CM)

Quebec Farm House With Distant Hills

By Jack Reid

This picture was taken on a bright, sunny day in Quebec, near St. Anne. Rural Quebec is one of my favorite places with its picturesque landscapes and brightly painted houses. The house in this photograph doesn't show Quebec's full splendor, so I used my imagination and added color to the house. When you paint, I encourage you to use your imagination too. Alter what you see in ways that please you. Others paint for their own enjoyment—my students paint for their amazement. Have fun!

[MATERIALS LIST]

- Burnt Sienna
- Cobalt Blue
- Raw Sienna
- Rose Madder Genuine
- Ultramarine Blue
- 1-inch (25mm) flat
- Nos. 6 and 12 rounds
- 300-lb. (640gsm) rough watercolor paper
- Miscellaneous supplies from page 11

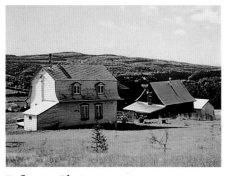

Reference Photo
I changed the colors in this photo to emphasize the splendor of the landscape.

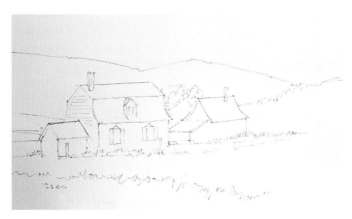

1 Sketch It Out
Sketch the farmhouse and distant hills.

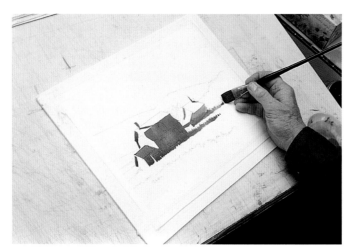

2 Paint the House and Barn
Mix Rose Madder Genuine and Cobalt Blue into a blue-gray wash. Using a 1-inch (25mm) flat, paint the shadows on the house and barn. Then turn the brush on its edge to paint the shadows of the house and barn.

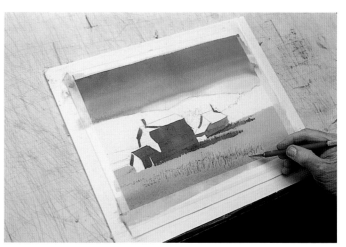

3 Paint the Sky and Foreground
Mix a blue wash with Cobalt Blue. Turn the painting upside down and brush clear water across the sky. Paint a graded wash with a 1-inch (25mm) flat brush over the rest of the sky. Turn the paper right side up and allow to dry.

Mix a wash with Raw Sienna tinted with Cobalt Blue. Paint the foreground grass area around the house, glazing slightly on the bottom part of the house. Use the 1-inch (25mm) flat. Continue to the bottom of the page with a graded wash of Burnt Sienna. While wet, score with a utility knife to indicate grass.

Paint the Distant Hills

4 With the same Burnt Sienna wash, paint the distant hills using a no. 12 round brush. Paint carefully around buildings to the grass line. Don't paint the area between the house and barn roofs. Then, using a no. 6 round brush, charge this area with pure Raw Sienna. Indicate the autumnal leaves on the distant hills with pure Burnt Sienna using the wet-on-wet technique.

Paint the House and Trees

5 Mix a red-purple wash with Rose Madder Genuine tinted with Cobalt Blue. Using a no. 6 round brush, paint the front of the house. Allow to dry. Mix a blue-green wash with Raw Sienna and Cobalt Blue, and then paint patches of trees on the hills using the no. 6 round. Add Ultramarine Blue to create a dark blue-green wash, and paint the fir trees to the right of the barn. Paint over the lower portion of the ground.

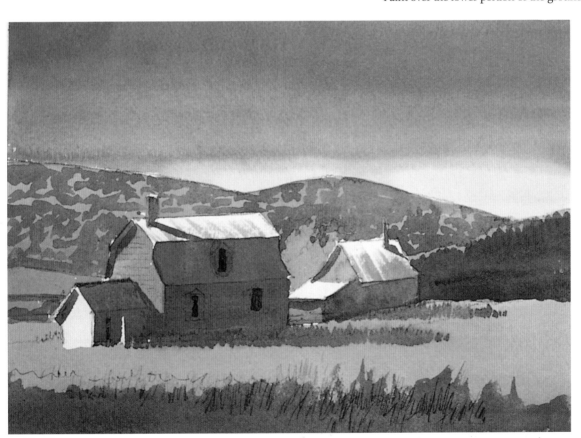

Complete the Painting

6 Mix a gray-brown wash with Burnt Sienna and Ultramarine Blue; then paint a door on the front of the barn using the 1-inch (25mm) flat. Be careful to leave barn roof exposed. Mix a dark-value wash with Ultramarine Blue and Burnt Sienna; then paint the windows using the 1-inch (25mm) flat. Finally, dry-brush Cobalt Blue on the roofs using the 1-inch (25mm) flat.

RURAL QUEBEC FARMHOUSE-ST. FERREOL LE NEIGES, P.Q. • JACK REID • 7½" × 11" (19CM × 28CM)

Sunset on Mountains

By Jack Reid

A watercolor painting is like a transparency; the pigments are transparent. This painting, with its luminous yellow and red sunlit sky behind dark clouds, beautifully demonstrates the importance of transparency. Keep this in mind when you paint. If you lose the transparent effect, you will lose the picture.

[MATERIALS LIST]

- Aureolin Yellow
- Burnt Sienna
- Cobalt Blue
- Rose Madder Genuine
- Ultramarine Blue
- Viridian
- ½-inch (13mm) flat
- Nos. 10 and 12 rounds
- 300-lb. (640gsm) rough watercolor paper
- Miscellaneous materials from page 11

Reference Photo
The sky is beautiful in this photo, but unfortunately you can't quite see the mountains. Use your imagination and fill in the appropriate values, colors and shapes.

1 | Sketch It Out
Use the reference photo to help you sketch the mountains and clouds.

2 | Paint the Sky
Turn the paper upside down and wet the paper with clear water. Begin the graded wash with pure Aureolin Yellow, adding Rose Madder Genuine to deepen and grade the color as you move toward the top of the sky. Use the ½-inch (13mm) flat.

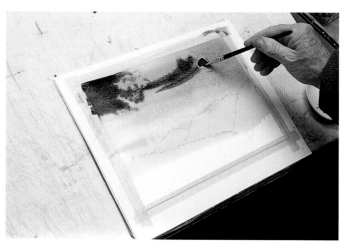

3 | Drop in Clouds
Turn right side up. While sky area is still moist, drop a Ultramarine wash wet-on-wet to indicate cloud patterns with a ½-inch (13mm) flat. Make your strokes loose and flowing. Lift lightly with a tissue and allow to dry.

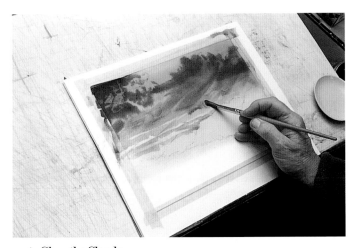

Glaze the Clouds

4 | Mix a Rose Madder Genuine wash and glaze below the clouds using either the no. 10 or no. 12 round.

Glaze the Mountains

5 | Add Aureolin Yellow to the wash, creating an orange-red wash. Glaze the distant mountains using a no. 10 round. Allow to dry. Then add Cobalt Blue to the wash—creating a purple gray—and glaze the mountains in the middle ground. Allow to dry. Finally, add Rose Madder Genuine and Ultramarine Blue, creating a dark purple wash, and glaze the mountains in the foreground. Use either of the round brushes.

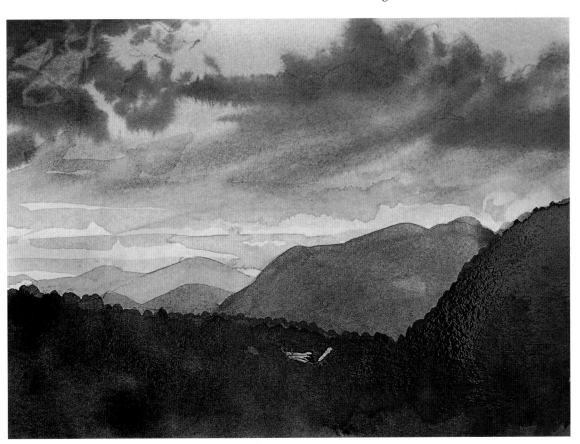

Complete the Painting

6 | Mix Ultramarine Blue, Burnt Sienna and Viridian into a very dark wash. The trick here is to make it a transparent wash, not opaque. Using a no. 12 round, glaze the foreground mountain on the right and over the foreground. If you don't have the right value, glaze over with the same wash until you achieve the effect you want.

MONTANA SUNSET, GLACIER NATIONAL PARK • JACK REID • 7½" × 11" (19CM × 28CM)

Mountain Winter Fantasy

By Jack Reid

This is my favorite painting in the entire book. Why? Because it holds all the elements I love: snow, mountains, atmosphere and feelings. It's the kind of scene you might see from a window in a mountain lodge, but I drew this one from my imagination. Although I sketched in a few details, I mostly drew it with my paints and brush. This is a classic example of the power you can find in a limited palette. I used only three pigments, and I painted it in only four steps. All the elements are simple. But don't let the simplicity of it fool you. It looks easier than it actually is. Let your imagination run wild on this one. Think about how your fantasy winter mountain would look. Paint loose and free, sketching what's in your mind's eye with your paints and brushes.

[MATERIALS LIST]

- Burnt Sienna
- Cobalt Blue
- Ultramarine Blue
- ½-inch (13mm) and 1-inch (25mm) flats
- No. 6 round
- 300-lb. (640gsm) rough watercolor paper
- Miscellaneous supplies from page 11

1 Sketch It Out
Sketch light pencil lines to indicate the mountains. You'll be drawing mostly with your paints, so make sure they are faint lines.

2 Paint the Clouds and Mountaintops
Moisten paper with clear water. With a 1-inch (25mm) flat brush, paint the clouds and mountaintops wet-on-wet with a soft gray wash mixed from Cobalt Blue and Burnt Sienna. Switch to a ½-inch (13mm) flat, and paint the blue sky in the top right corner using a pure Cobalt Blue wash. Allow to dry.

3 Grade the Mountaintops to Create a Blurred Effect

Mix a blue-gray wash with Cobalt Blue and Burnt Sienna. With a ½-inch (13mm) flat brush, paint the shadows on the mountains. Then, brush clear water along the top of the mountains and below the bottom edge of shadows to create a blurred effect.

4 **Paint Shadows on the Mountains**
Continue painting shadows as you move toward the bottom of the mountain.

5 **Paint the Outcrops and Complete the Painting**
Paint the rock outcrops in the sunlight with a pure Burnt Sienna wash and a no. 6 round. Add Ultramarine Blue to the wash, and then paint the outcrops in shadows. Decreasing the value will strengthen the sense of distance, so dilute the wash for outcrops on the distant mountains on the left. Lift with a tissue to soften shadows.

MOUNTAIN WINTER FANTASY • JACK REID
• 7½" × 11" (19CM × 28CM)

SKIES

Throughout the ages, skies have been a favorite subject matter for artists. Experiment with wet-on-dry techniques while adding the look of atmosphere to your paintings with stormy thunderheads and cumulus clouds. Paint a soft, summer sky with thin, wispy cirrus clouds stretching across the sky, which is a good wet-on-wet lesson. The sunset over the lake—with the wet-on-wet altostratus clouds—uses the same colors in the sky and the lake.

Thunderhead Clouds

By Brigitte Schreyer

In this chapter you'll play with wet-on-wet and wet-on-dry techniques as you hint at a looming thunderstorm. If you want the sky to be the star of your painting, then drop the horizon line down and keep the landscape very simple.

Reference Photo

Remember, reference photos are a starting point. You don't have to copy exactly what is in each photo. Add and subtract details until you find just the right pleasing composition.

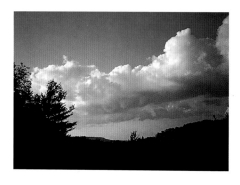

[MATERIALS LIST]

- Antwerp Blue
- Burnt Sienna
- French Ultramarine
- New Gamboge
- Raw Sienna
- ½-inch (13mm) and 1-inch (25mm) flats
- No. 4 script liner (also called a rigger)
- 300-lb. (640gsm) cold-pressed paper
- Miscellaneous materials from page 11

Complete the Sketch

1 | Use the reference photo to help you sketch in the scene with a 2H pencil.

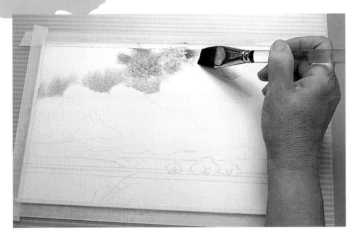

Begin the Clouds

2 Using the 1-inch (25mm) flat, wet carefully around the puffy clouds. Try not to use too much water—just enough to have a light shine on your paper. Load your brush with a little watery Antwerp Blue and drop it into the wet sky right around the clouds. Add a bit of French Ultramarine closer to the top of the sky. The two colors will float together, leaving a few lighter spaces in between.

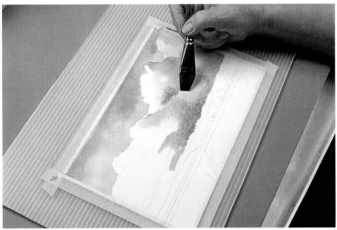

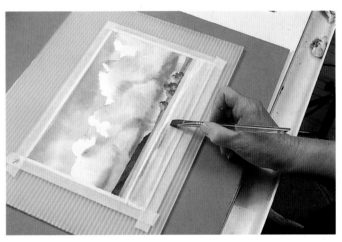

Add the Cool and Dark Grays

3 Indicate the direction of your light source to help you place the shadows of the clouds, trees and so on. Next, prepare two mixtures: French Ultramarine plus a touch of Burnt Sienna (cool gray) and Burnt Sienna plus a touch of French Ultramarine (warm gray). Also, have a watered down Raw Sienna ready. With the 1-inch (25mm) flat, wet the shadow sides of the clouds slightly and drop in the cool and warm grays, as well as a bit of the Raw Sienna. Make sure that most of the cool gray is on the underside of the clouds.

Finish the Clouds and Begin the Landscape

4 While the clouds are still wet, dry your flat and pull down some dark paint from the undersides of the clouds toward the horizon. This is a quick and creative way to add the appearance of rain falling in the distance.

Let dry. Mix a little Antwerp Blue, Burnt Sienna and a touch of Raw Sienna; then paint the dark green hills wet-on-dry with the ½-inch (13mm) flat. Add a little watered down Raw Sienna to the mixture and paint the distant field. Paint the yellow canola field with a watery New Gamboge mixture. Use the ½-inch (13 mm) flat for both.

Add the row of deciduous trees in the middle ground with Raw Sienna on the sunny side, and use Antwerp Blue plus a touch of Burnt Sienna on the shadow side of the trees. Scrape in the trunks and branches with the slanted brush handle. Mix a thin wash of French Ultramarine plus a touch of Burnt Sienna, and paint the distant hill using a ½-inch (13mm) flat.

Wet the foreground. With a 1-inch (25mm) flat—using gentle, horizontal strokes—float in Burnt Sienna, Raw Sienna and Antwerp Blue. They'll mix softly on the wet paper and give the illusion of a meadow.

5 **Stroke in the Foreground Grasses**
Hold your flat upright and vertically stroke in some darker grasses in the foreground with a heavier mixture of Antwerp Blue and Burnt Sienna.

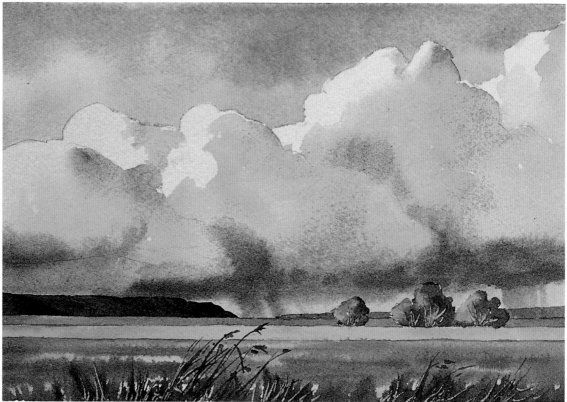

6 **Add the Finishing Touches**
While these foreground grasses are still damp, but not shiny, scrape some grasses into the foreground using the handle tip of your flat brush. As scraping will give the illusion of lighter grasses, use a long pointed no. 4 script liner to add a few darker and longer grasses to give depth to the painting.

THUNDERHEAD CLOUD • BRIGITTE SCHREYER • 7½" × 11" (19CM × 28CM)

Breaking Clouds

By Brigitte Schreyer

These cumulus clouds remind me of puffy cotton balls floating in the sky, and are a personal favorite of mine. I like to refer to them as *prairie clouds*. Cumulus clouds are usually portrayed in my paintings with wheat fields or large, open meadows, which reflect the many years in the Canadian prairie. You'll be using mostly wet-on-dry here, since you do want to retain some hard, white edges at the top of the clouds.

[MATERIALS LIST]

- Antwerp Blue
- Burnt Sienna
- French Ultramarine
- Raw Sienna
- ½-inch (13mm) and 1-inch (25mm) flats
- No. 4 script liner (also called a rigger)
- 300-lb. (640gsm) cold-pressed paper
- Miscellaneous materials from page 11

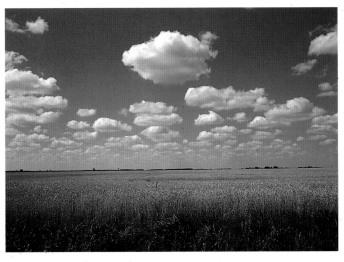

Reference Photo
As you can see in this reference photo, the overhead clouds are larger and puffier. There are also bigger patches of blue sky in between. Then, about halfway down to the horizon, the cloud shapes will get closer together, simpler and also narrower.

1 | Complete the Sketch
Use the reference photo to help you sketch in the scene. Again, use the photo as guide, not a blueprint. Draw your horizon line approximately one-third from the bottom. This leaves you two-thirds of the paper to paint this wonderful prairie sky. Add the clouds, a fence post and the distant tree line.

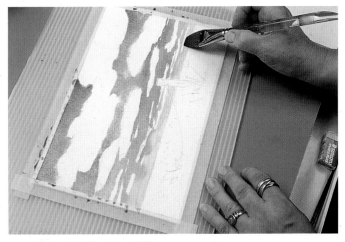

2 | Begin the Clouds and Sky
Mix French Ultramarine with a touch of Burnt Sienna; then paint around the top and bottom of the large cloud wet-on-dry using a 1-inch (25mm) flat. Dip the flat in thinned Antwerp Blue and continue painting around the middle and flatter clouds. Be sure to overlap the French Ultramarine, Burnt Sienna mixture and add clear water down to the horizon line.

Shade the Clouds

3 | Using the 1-inch (25mm) flat and a warm gray mixture of French Ultramarine plus just a touch of Burnt Sienna, follow the bottom outline of the clouds. Then, lose the upper hard edge of your strokes with a "thirsty" brush (see page 10) by dragging it across the hard edge of the French Ultramarine and Burnt Sienna mixture.

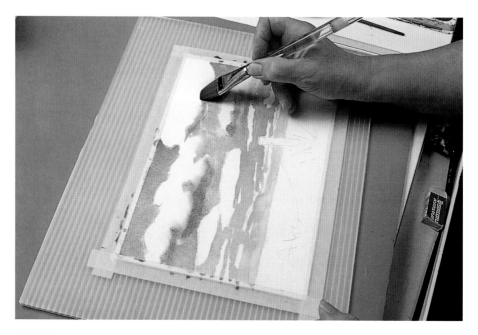

Paint the Trees and Fields

4 | Using your 1-inch (25mm) flat, drop a thicker mixture of Antwerp Blue and Burnt Sienna just above the horizon line to shape the distant tree line. Since the sky is still a bit damp, this will give you a nice soft, blurry effect.

Paint the wheat field wet-on-dry with Raw Sienna plus a bit of Burnt Sienna added at the very foreground. Make a heavier Antwerp Blue, Burnt Sienna mixture; then vertically stroke in the foreground grass with your 1-inch (25mm) flat. Add some thin, horizontal lines to the field with a French Ultramarine, Burnt Sienna mix.

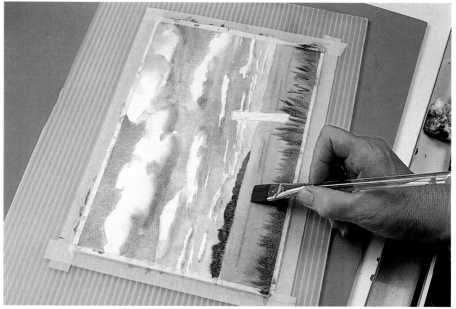

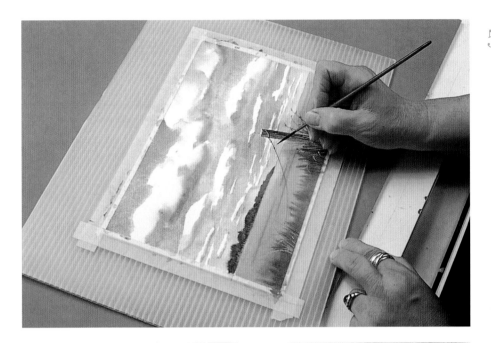

Finish the Grass and Paint the Fence

5 Scrape light grasses in the foreground with the handle of your brush. Paint the fence post with the ½-inch (13mm) flat using a watery mix of Burnt Sienna on the left side and thinned French Ultramarine mix on the right side. They'll blend into a nice graded wash, making the fence post appear round. As the wash is drying, add cracks with the French Ultramarine, Burnt Sienna mixture and a few vertical strokes using your ½-inch (13mm) flat.

While the fence post is still damp, scrape in a little line for a sunlit barbed wire. Paint the wire in one sweep using a mix of Burnt Sienna plus a touch of French Ultramarine and your no. 4 script liner. Turn the painting upside down and start at the post.

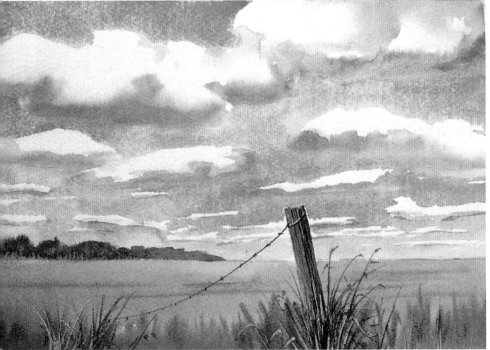

Complete the Painting

6 Add a few long grasses around the post using a mixture of Antwerp Blue plus a touch of Burnt Sienna using the no. 4 script liner. Erase the pencil lines, especially in the white, puffy clouds, and any finishing details as necessary.

PRAIRIE CLOUDS • BRIGITTE SCHREYER • 7½" × 11" (19CM × 28CM)

Stormy Sky

By Jack Reid

This scene is from the foothills of the Rocky Mountains near Banff, Canada. The dominant focus in this picture is the dark, stormy sky, which contrasts with the vibrant orange grasses in the foreground.

[MATERIALS LIST]

- Aureolin Yellow
- Burnt Sienna
- Cobalt Blue
- Rose Madder Genuine
- Ultramarine Blue
- 1-inch (25mm) flat
- No.8 round
- 300-lb. (640gsm) rough watercolor paper
- Miscellaneous materials from page 11

Reference Photo
The sky is focus for this demonstration, so go ahead and use that artistic license to fill in the landscape as you like.

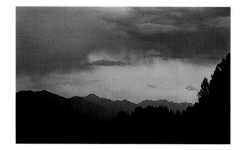

Sketch it Out
1 | Sketch an outline of the foothills and trees.

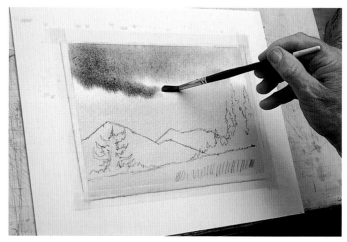

Paint a Stormy Sky
2 | Mix a medium orange wash of Aureolin Yellow and Rose Madder Genuine. With a 1-inch (25mm) flat, tint the entire paper with a flat wash. Add Cobalt Blue to the mixture and drop the pigment into the wet sky using a no. 8 round. This soft gray color sets the backdrop for a moody, stormy sky.

Paint the Foreground
3 | Mix a deep, rich, luminous orange wash from Aureolin Yellow and Rose Madder Genuine. Then, paint the foreground grass in a flat wash using the 1-inch (25mm) flat. The splash of color breaks up the dullness of the background and emphasizes the dark sky.

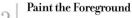

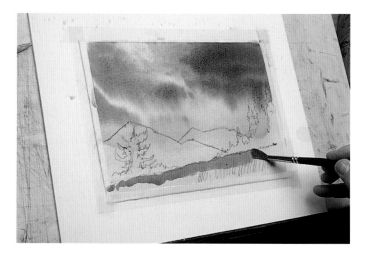

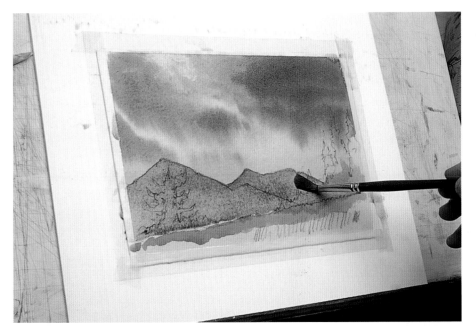

Render the Distant Mountains

4 | Tint Cobalt Blue with Rose Madder Genuine into a purple-gray wash. Using a no. 8 round, paint the distant mountains in a flat wash.

STORMY SKY • JACK REID • 7½" × 10" (19CM × 25CM)

Add the Foreground Grass and the Distant Tree Line

5 | Mix Burnt Sienna and Ultramarine Blue into a medium brown wash. With a no. 8 round, paint the foreground grasses. Mix Burnt Sienna and Ultramarine Blue into a grungy, dark brown wash. With a no. 8 round, flat wash the silhouette of distant trees on the right side. While wet, angle a utility knife and score the trees to give the impression of a few exposed birch trees. Notice how this breaks up the mass of dark color.

Sunset

By Brigitte Schreyer

This sunset reference photo will only give you a rough idea about the colors and the feeling of a sunset on a lake. Since still waters will always reflect the sky, you must work quickly in this wet-on-wet demonstration. You'll use the same colors for the sky, as well as the water.

[MATERIALS LIST]

- Burnt Sienna
- French Ultramarine
- New Gamboge
- Permanent Rose
- Winsor Red
- ¾-inch (19mm) and 1-inch (25mm) flats
- No. 4 script liner (also called a rigger)
- 300-lb. (640gsm) cold-pressed Arches paper
- 2H pencil
- Miscellaneous materials from page 11

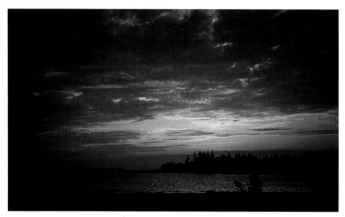

Reference Photo
Isn't this sunset beautiful? It's a great starting point for a painting, but leaves room for interpretation.

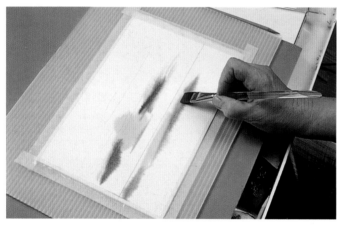

Begin the Sky

1 Indicate your horizon line and a couple of the main clouds. You're not always in command when you're working wet-on-wet, so it's better not to draw in your details at this stage. You'll want the center of interest (the bulrushes) in the brightest light to have a backlit effect. Therefore, wait until your clouds are completely dry; then decide where to place the bulrushes.

Wet the entire paper. Load your ¾-inch (19mm) flat with a pure New Gamboge mixture and drop it in a circular motion somewhat off center on top of the horizon line. Next, bring the same brush down below the horizon line in a horizontal stroke. Clean the brush, load it with pure Winsor Red and add a couple strokes on each side of the yellow. The colors will blend a little.

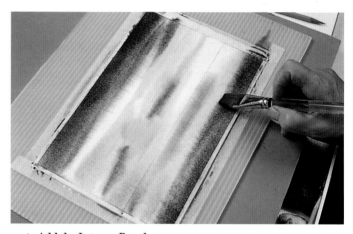

Add the Intense Purple

2 Now mix a large puddle of French Ultramarine with a touch of Permanent Rose. Using a 1-inch (25mm) flat, add this purple mix to the very top and very bottom of your wet paper. Add a little water to this mixture and stroke it above and below the yellow and red washes using the 1-inch (25mm) flat. Move quickly to the next step.

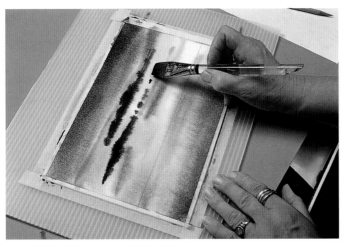

3 **Create the Backlit Clouds**

Right now the paper is still damp, but it will be drying quickly, so you'll have to work fast. Load your 1-inch (25mm) flat with a thick mixture of French Ultramarine—plus a bit more Permanent Rose than you used in step two—and lightly touch the damp paper. You'll get a nice soft and dark backlit cloud effect.

4 **Drop In the Backlit Island**

Add a little more French Ultramarine to the mixture from the previous step. Create the appearance of a distant, backlit island by dropping the dark blue mix above and below the horizon line. With the tip of a thirsty ¾-inch (19mm) flat, lift out a light water line from the middle of the island, thus dividing the island from its reflection.

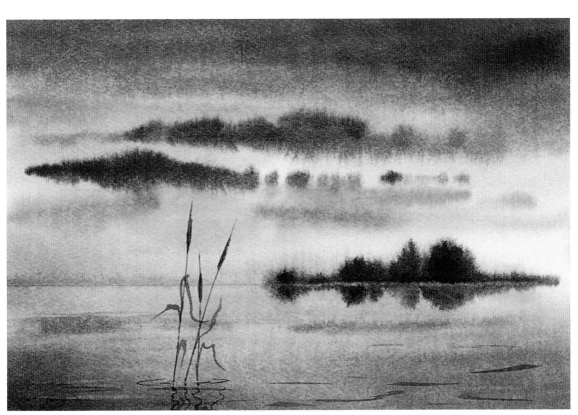

5 **Complete the Painting**

Using a no. 4 script liner loaded with an equal mixture of Burnt Sienna and French Ultramarine, paint in the bulrushes wet-on-dry. Finish it off with a few horizontal water lines using the ¾-inch (19mm) flat and a mix of French Ultramarine plus a touch of Permanent Rose.

SUNSET AT THE LAKE • BRIGITTE
SCHREYER • 7½" × 11" (19CM × 28CM)

step-by-step *demonstration*
Soft Summer Sky

By Brigitte Schreyer

This photo gave me the idea of painting some wispy side-to-side clouds using the wet-on-wet technique. This simple exercise teaches you how to add a beautiful summer sky to your paintings. Practice and soon you'll be able to spice up any painting with a little sunshine!

Reference Photo
Use the sky image as reference, then add your own landscape or follow along with mine.

[MATERIALS LIST]

- Antwerp Blue
- Burnt Sienna
- French Ultramarine
- Raw Sienna
- 1-inch (25mm) flat
- No. 4 script liner (also called a rigger)
- No. 5 round
- 300-lb. (640gsm) cold-pressed paper
- Miscellaneous materials from page 11

1 **Begin to Lay in the Sky**
Avoid pencil marks in your final piece and only indicate the horizon line, which is two-thirds from the top of your paper.

Wet the entire paper. Load the 1-inch (25mm) flat with thinned Raw Sienna and swipe it above the horizon line. It will bleed a bit into the bottom part, but that's OK. Clean the brush, load it with watery Antwerp Blue and stroke it right above the yellow. Repeat, but this time use French Ultramarine mixed with a very small amount of Burnt Sienna. Repeat the French Ultramarine strokes left to right, leaving some white spaces.

2 **Define the Sky With Dark Values**
While the paper is still damp, load your 1-inch (25mm) flat with a darker value of Antwerp Blue and stroke in some darker lines on top of the blue and into the yellow area.

Add the Landscape

3 | The bottom part of the paper is now almost dry. Using the 1-inch (25mm) flat and thinned Raw Sienna, carefully paint below the horizon line. Continue to overlap strokes toward the base of the paper. Now dip your brush into an Antwerp Blue, Burnt Sienna mixture and blend these colors into the foreground with horizontal brushstrokes. Mix Burnt Sienna plus a touch of French Ultramarine; then horizontally stroke in some lines—barely touching the paper—with a 1-inch (25mm) flat.

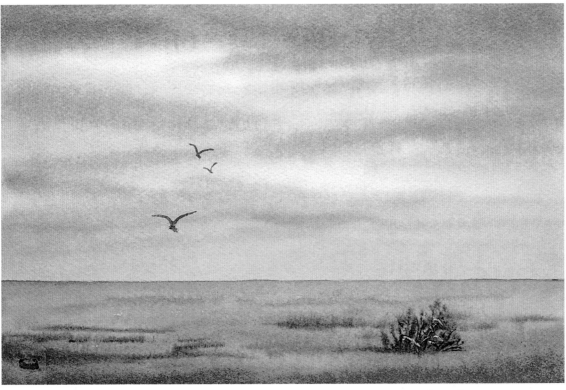

Complete the Painting

4 | Add a few foreground plants by making a small puddle of thick Antwerp Blue mixed with a little Burnt Sienna. Using a no. 5 round, drip some of the dark green color onto the damp paper in the shape of a little bush. Then, with the tip of the brush handle, scrape a few highlights into your foreground foliage.

Since all the strokes in this sky, as well as on the meadow, are horizontal, add some birds with the no. 4 script liner. This gives you the illusion of a "vertical" object in your painting. You can also add fences, railings, etc. to break up the horizontal composition of the painting.

SOFT SUMMER SKY • BRIGITTE SCHREYER • 7½" × 11" (19CM × 28CM)

BUILDINGS

I love to draw and paint buildings. All of the subjects in following demonstrations have unique

characteristics. Capturing this is artistically challenging, but you'll have a great feeling of achievement when you

succeed. I love the way the light affects the textured surface of an old barn, and how sunlight bounces shadows and

reflected light off the shiny surface of a white building. I could go on, but this book is a visual tool, and the best way I

know to learn is to begin painting!

Winter Barn
By Jack Reid

Before painting any picture, you must decide the time of day and the lighting conditions. This painting is a winter scene in the late afternoon just as the sun is setting. You'll complete this demo with a graded wash, which is ideal for rendering the strong light of the sky.

[MATERIALS LIST]

- Burnt Sienna
- Cobalt Blue
- Raw Sienna
- Ultramarine Blue
- ½-inch (13mm) and 1-inch (25mm) flats
- No. 8 round
- 300-lb. (640gsm) rough watercolor paper
- Miscellaneous materials from page 11

1 Sketch the Barn, Fence and Rails
I eliminated the silo that was originally in my reference photograph. You have the freedom to include or eliminate elements in any of your paintings. The goal is to create the best composition possible, so go ahead and flex those creative muscles!

2 Paint the Sky and Barn
Prepare a medium-value wash of pure Burnt Sienna. Turn the paper upside down and paint a graded wash over the sky with the 1-inch (25mm) flat. Paint the front of the barn and part of the foreground with graded washes of Burnt Sienna using the 1-inch (25mm) flat. Let dry.

Add Ultramarine Blue to the Burnt Sienna wash until you get a gray-brown wash. Paint the background tree line, the attached buildings, the shadow across the front of the barn and the small fence post in the foreground using a ½-inch (13mm) flat. Let dry.

3 | **Paint the Clouds, Barn Roof and Snow Drifts**
Mix a wash of Cobalt Blue tinted with Burnt Sienna. With a no. 8 round, glaze late evening clouds across the sky and paint the barn roof. Let dry. Then, using the same brush and wash, paint the soft shadows along the edges of snowdrifts in the foreground. Let dry.

4 | **Drybrush Texture on the Barn**
Add Raw Sienna to the Cobalt Blue, Burnt Sienna wash to create a medium brown. With a ½-inch (13mm) flat, drybrush over the front face of the barn, the roof of the two sheds, the sides of the sheds (to indicate texture on the boards) and the appearance of rust on the roofs.

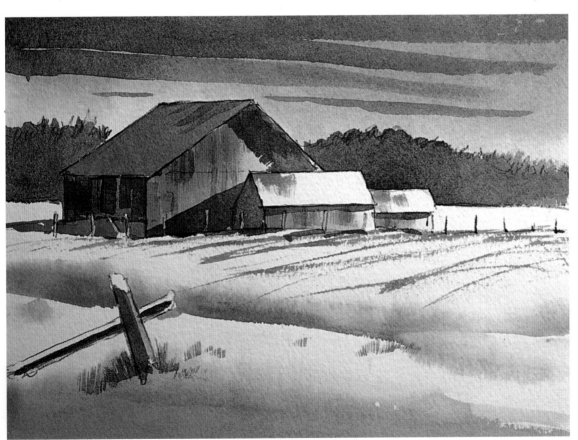

5 | **Finishing Touches**
Stand back and take a look at your finished painting. See if you need to add any more finishing details. Is there enough texture on the barn? Do the cast shadows look dark enough against the snow? Once you are satisfied, sign your name and pat yourself on the back.

WINTER BARN • JACK REID • 7½" × 11"
(19CM × 28CM)

Snow Shed

By Grant Fuller

One of the best things about watercolor, and art in general, is how versatile it is. Being an artist means having a license for personal expression and creativity. As you have seen in this book, styles vary from artist to artist, as do techniques. You've just completed a building in snow demonstration by Jack Reid; now see how Grant Fuller interprets the subject.

Grant Fuller's Snow Shed Demonstration

I began this painting with a sketch developed from several source photos. The shed was not covered in snow, but I had other snow reference pictures that provided all the information necessary to prepare this simple drawing. I needed other reference photos to start me thinking about lighting. Sunlight on snow can be a very striking sight, but I didn't want it to contrast so much that it would lose that soft shape.

[MATERIALS LIST]

- Burnt Sienna
- Ultramarine Blue
- ½-inch (13mm) and 1-inch (25mm) flats
- Nos. 3 and 8 rounds
- 140-lb. (300gsm) cold-pressed paper
- Miscellaneous materials from page 11

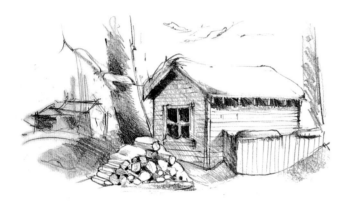

1 | Complete the Sketch
Copy this sketch onto your watercolor paper. You don't have to be as detailed as I was with your sketch. Feel free to include or delete any details.

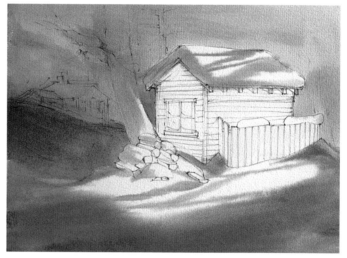

2 | Begin the Dark Snow Areas
Mix a variety of Burnt Sienna and Ultramarine Blue combinations so the grays vary somewhat. Wet the entire paper. When the shine begins to fade, test it with the lightest value of Burnt Sienna, Ultramarine Blue mixture using a very dry 1-inch (25mm) flat. If it runs too much, wait a few more minutes and try again. Each subsequent brush load should have less water and more pigment than the preceding one. As soon as more water than pigment is added, it washes away what has already been painted.

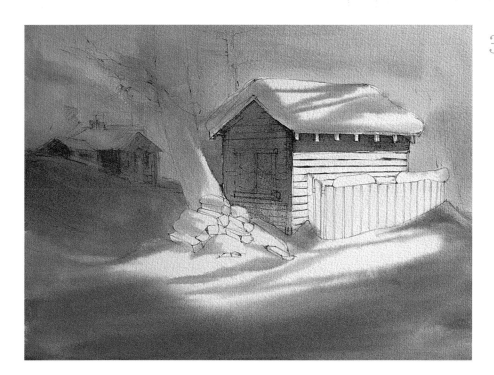

Glaze the Second Layer

3 | Let the paper dry and mix a slightly darker version of the Burnt Sienna, Ultramarine Blue wash. Paint the cast shadow under the eaves and over the shed wall using the ½-inch (13mm) flat. Once again, change the mixture on the brush slightly each time.

Suggest the second building in the distance with a lighter mix and a drier ½-inch (13mm) flat.

These washes and glazes are what will give your watercolor its unique appearance. The hard part is getting command of the strokes and leaving them alone.

Add Some Details

4 | Use a thin wash of pure Burnt Sienna for the lightest color of the fire logs. Load the no. 8 round with pure Burnt Sienna very thin, for the lightest color on the fire logs. Shape the shadow side of the logs by adding some of the Ultramarine Blue, Burnt Sienna mix.

Paint the spaces in the fence and the cast shadows on the shed with the wash you used in step one for the shadows on the snow.

Shape the small areas of snow—such as on the logs and fence—by drawing the brush along the desired shape with the shadow color, quickly rinsing the brush; then lightly squeezing it dry and touching the edge of the wash while it is still wet. (This is another way of getting a graded wash.)

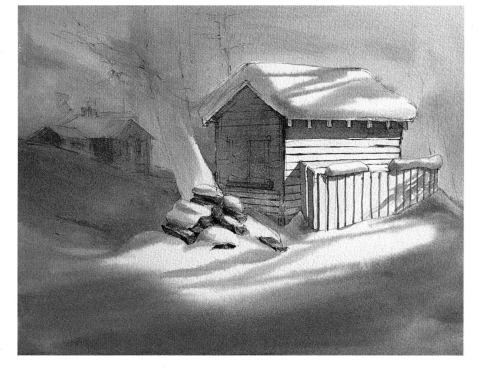

Paint the Trees

5 Paint the distant trees using a light blue-gray and alternate between the nos. 3 and 8 rounds. Normally this light work in the background is done before the darker values go in, but this time it is necessary to see how busy the painting is in the foreground. The distant trees do not interfere with any other elements in the composition and are placed where they enhance the design.

Next, paint the large dark tree in the foreground using a thicker mixture of Burnt Sienna and Ultramarine Blue using the no. 8 round. Take care to avoid the snow on the branch. Leave a bit of lighter brown near the base of the trunk to show it's in sunlight.

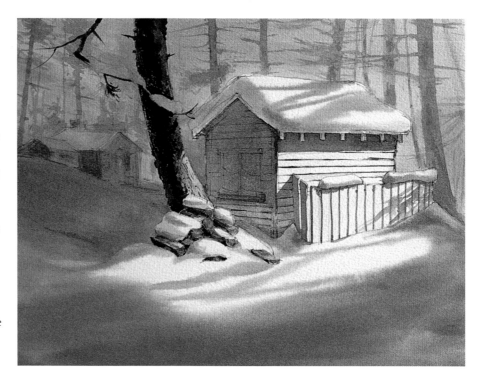

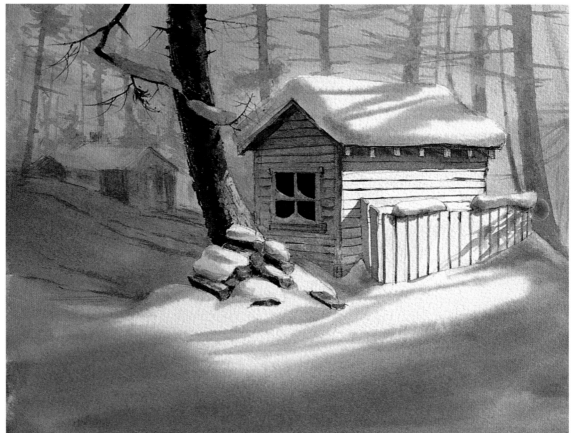

Finish the Painting

6 Finally, add the darkest darks for the window and some smaller branches on the main tree. Use the no. 3 round.

This is not a complicated exercise, but it involves building the layers of colors slowly. When you can gain enough control of the paint, paper and brushes to execute this picture, you will be able to apply these methods to any other subject.

SNOW SHED • GRANT FULLER • 11" × 15" (28CM × 38CM)

White Church

By Grant Fuller

Buildings are just boxes with other things stuck to them. Here is one main box with two smaller boxes attached. Start with the main large box, and when you are happy with that shape, the others will follow.

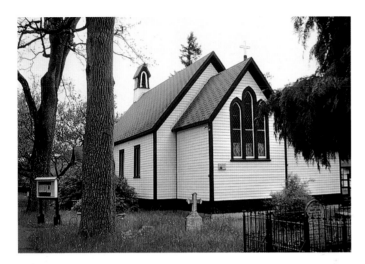

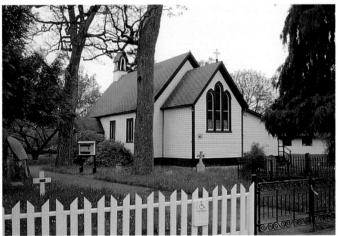

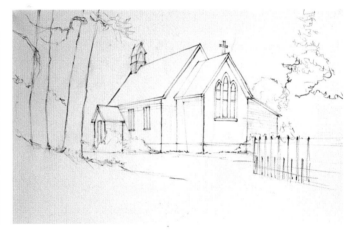

Reference Photos

If you take the perfect photograph, you can just copy it. I've never had such good luck, so I'm always painting from several photos of the same subject. I was hoping for a sunny day, but it was overcast. The trees were blocking my view of the church, and although I like the little white fence, it would be a busy distraction. Don't hesitate to arrange the objects in your painting just as you wouldn't shy away from placing your living room furniture to suit your taste.

Sketch the Building

1 | Practicing in a sketchbook is a great way to learn to see past all the distracting ornaments like gables, steps and railings, stonework or pillars. Find that main box, sketch it out and be sure to get the proportions right. The rest is much easier. Once you are satisfied with your drawing, transfer it to your watercolor paper.

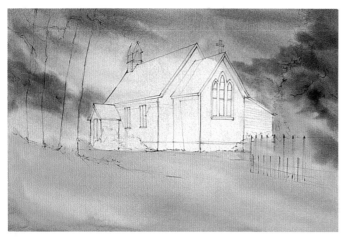

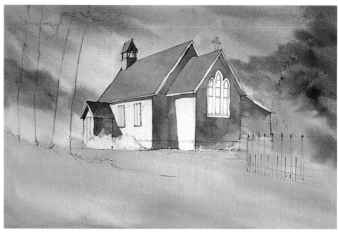

Begin the Large Areas of Color

2 Wet the paper with the 1-inch (25mm) flat, except for the building. This will prevent the paint from running into it. Dry the flat and use it for all elements in this step. Your brush always needs to be very dry when working on the wet paper, or the pigment will run flat and the distinct shapes of the soft clouds will be lost. Paint the sky dry-on-wet with cool grays from a mix of very thin Cadmium Orange and Cobalt Blue. Use a stronger mix (less water) of the same sky colors for the clouds. Mix Raw Sienna with some Phthalo Green for the grass and vary the mixture to keep large areas from looking too flat. Create the dark trees with a mix of Burnt Sienna and Phthalo Green. Dry the painting before proceeding, as the rest of the painting will be done wet-on-dry.

Start the Building

3 Strong sunlight also means strong shadows, so with the light source on the left, use Ultramarine Blue and Burnt Sienna on the walls facing right. Let the paint run together on the paper, avoiding flat color. The no. 8 round works well for this job.

Paint the roof with Burnt Sienna and just a small amount of Dioxazine Violet. Again, vary the mixture on each brush load. Make the cast shadows on the front roof with a second glaze (or layer) of the same Burnt Sienna, Dioxazine Violet mixture.

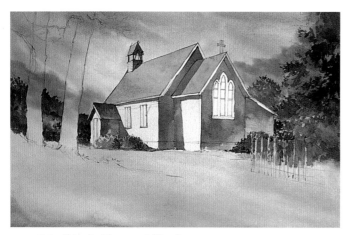

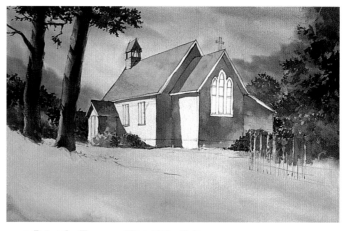

Splash in the Trees and Shrubs

4 Using a mix of Raw Sienna plus a bit of Phthalo Green and the no. 8 round, start to splash in some trees and shrubs. Work with the lightest colors first; then paint dark patches over the light areas after the first washes are dry.

Paint the Trees and Detail the Foliage

5 Paint the two large tree trunks with the ½-inch (13mm) flat and a mixture of Burnt Sienna and Dioxazine Violet. Draw any details, branches and shadows with the same colors and the no. 8 round.

As the shrub and foliage areas dry, go back in and create depth and dimension with darker layers of colors.

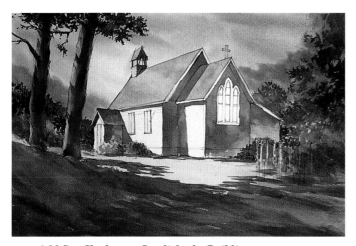

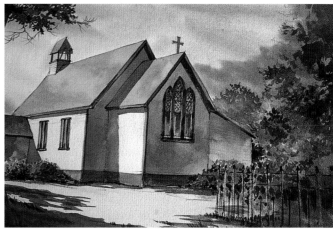

Add Cast Shadows to Spotlight the Building

6 | Boldly sweep Cobalt Blue, Burnt Sienna, Raw Sienna and Phthalo Green onto the paper allowing brushstrokes to show where they want, and let the pigments mix on the paper. Use the 1-inch (25mm) flat for the bold strokes and the no. 8 round at the very end of this stage to add wild grass. Don't make your strokes too carefully or the painting begins to lose its life.

Detail the Church

7 | Paint the trim, window frames, windows and iron fence with Burnt Sienna and Dioxazine Violet. Go in a second time with the same mixture for the darker values. Glaze a few more dark greens in the foreground. Don't get too tight with the details. A new no. 8 round will have a good enough point to get into these areas, but it's large enough to resist overworking.

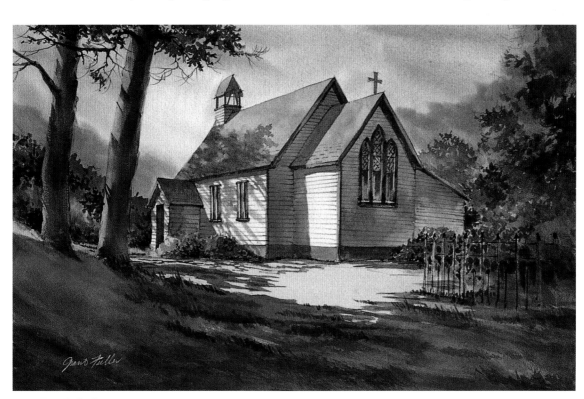

ST. MARY'S •
GRANT FULLER •
15" × 22"
(38CM × 56CM)

Finish the Painting

8 | You can try to freehand the siding or use a wooden straight edge angled off the surface of the paper. Hold the no. 3 script liner normally, but with the thumb against the top edge. The straight edge will keep the brush off the surface, but your lines will widen as the brush gets closer to the paper.

Add a few cast shadows on the building using the roof color with Burnt Sienna and Dioxazine Violet. Create the shadows on the white sides with Ultramarine Blue and Burnt Sienna. Use the ½-inch (13mm) flat.

If you find certain areas are too dark, soften them with the no. 8 round and clean water. Just be sure to blot the brush with paper towel or tissue. Press firmly to be sure the paint will be lifted.

Log Cabin

By Grant Fuller

This log cabin was the home of Charles M. Russell, famous American artist, when he visited Montana. It is now a preserved heritage building. Jack Reid, myself and our wives were extremely fortunate to be the guests of Glacier National Park for a week in the summer of 1997, when we were provided with a beautiful cottage on the lake, right next door to this national treasure. I wasn't about to pass up the opportunity to paint it.

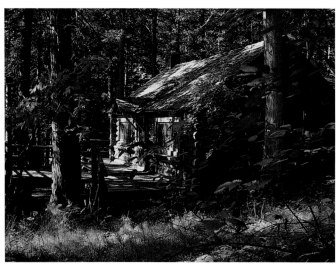

Reference Photo

[MATERIALS LIST]
- Burnt Sienna
- Cobalt Blue
- Dioxazine Violet
- New Gamboge
- Phthalo Blue
- Phthalo Green
- Raw Sienna
- Ultramarine Blue
- ½-inch (6mm), ½-inch (13mm) and 1-inch (25mm) flats
- Nos. 5 and 8 rounds
- No. 3 script liner (also called a rigger)
- 140-lb. (300gsm) cold-pressed paper
- Miscellaneous materials from page 11

Study Interlocking Shapes
The hardest part of the drawing is the corner structure. Understanding how logs are shaped and fitted is essential. Notice how the stacked logs have spaces that need to be filled with some form of grout.

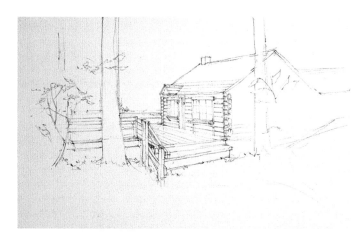

Sketch the Basic Structure and Trees
1 Take care with the front of the cabin, the steps and the railing. Use simple shapes for the rest of the drawing.

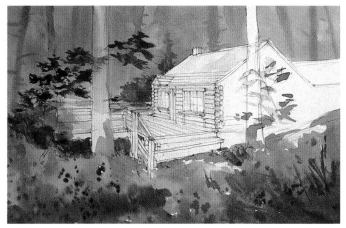

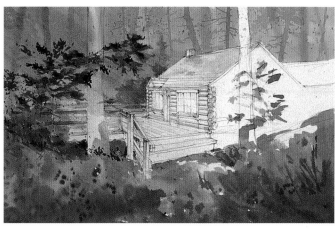

2 **Begin With Large Areas of Color**

Wet the paper, except for the cabin and two large trees. Using a 1-inch (25mm) flat, thinly flat wash Cobalt Blue in the background and add Raw Sienna for the foreground. Vary the greens in the foreground by scrubbing and spattering bits of Phthalo Green with Burnt Sienna and New Gamboge. As the paper begins to dry slightly, make the background tree trunks with streaks of Cobalt Blue using the fairly dry edge of the 1-inch (25mm) flat. Wash a warm underpainting on the cabin with New Gamboge and just a bit of Dioxazine Violet. Dab in the large groups of leaves with various combinations of yellow, green and brown.

3 **Detail the Trees and Building**

When the paper is dry, draw some slightly more detailed tree trunks right over the top of the background with branches using the no. 8 round and more Cobalt Blue. Drybrush a bit of New Gamboge into the top left corner to break up the cool color across the top. Glaze the foreground with the Cobalt Blue and Raw Sienna if necessary.

Check the drawing and make sure the lines are dark enough. Reinforce them if necessary, but don't make them so dark they stand out in the finished work.

4 **Add the Dark Areas**

Try to think of all the dark objects as a single shape and paint them in a continuous motion. Use the no. 8 round with Ultramarine Blue, Burnt Sienna, Dioxazine Violet and a bit of Cobalt Blue. To keep the mix from becoming one solid color, avoid stirring it together on the palette and let it run together on the paper. You'll get a good connection between the darks and also prevent the monotony of dead, flat color. Start the large tree trunks using the ½-inch (13mm) flat and a light mix of Burnt Sienna and Ultramarine Blue. You can switch to the no. 8 round when necessary, and vary the paint mixtures slightly as you progress along.

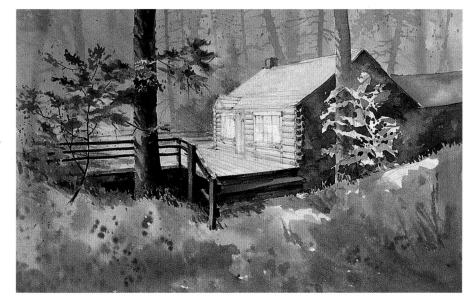

5 | Paint the Dark Grass

Experiment with the different marks a 1-inch (25mm) flat makes when you press it on a palette. Split, bend or twist the hairs of the flat. Avoid the tell-tale marks of tidy, square shapes. Once you are satisfied, scrub on a dry mixture of Burnt Sienna, Phthalo Green, Raw Sienna and Phthalo Blue for the trees. Modify the mixture by adding Raw Sienna for some areas and Pthalo Blue in others. Use the no.5 round and the no. 3 script liner for the thin branches and vines. Scratch a few light bits back in if the foreground goes too dark.

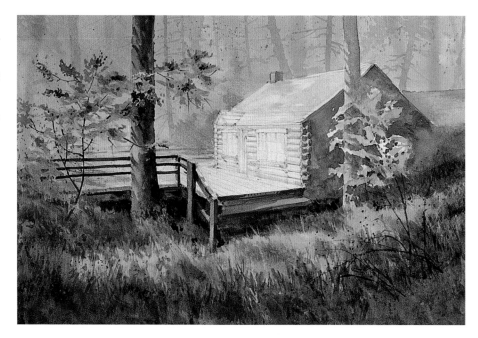

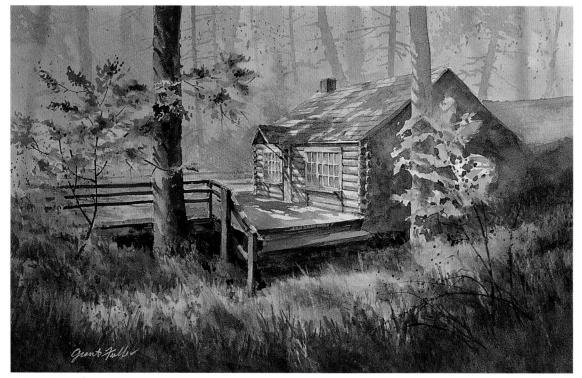

6 | Add the Finishing Touches

Use a no. 5 round for much of the rendering of the cabin. Once again, the main ingredient is Burnt Sienna toned down with Ultramarine Blue. Start shaping the logs by darkening the bottom half of each. Block in the window panes with a slightly bluer mix. Let dry and add a darker value to the bottom edge of each log. All logs should have three values—light, medium and dark— to give them some shape.

Paint the cast shadows on the cabin with Ultramarine Blue and Burnt Sienna using the ¼-inch (6mm) flat. Add some Dioxazine Violet and Cobalt Blue to the mix to exaggerate the colors. Create the appearance of shingles on the roof with the same ¼-inch (6mm) flat. Assess the composition and tone down spots that are distracting or increase the contrast in the important areas. You want the dominant point of interest to be the front of the cabin.

HOME OF CHARLES
M. RUSSEL •
GRANT FULLER •
15" × 22"
(38CM × 56CM)

Stone House With Autumn Foliage

By Grant Fuller

I love paintings that appear to be elaborate works with a certain attention to detail, but when broken down into stages, they are very straight forward and simple to execute. This painting requires taking care with the drawing and being patient with the painting process. I don't like spending long hours on a painting, so I tend to work quickly and loosely. Yet, from a few feet away, the painting looks quite refined. This method of working makes painting fun for me, and I sincerely hope I can help make it fun for you.

[MATERIALS LIST]

- Burnt Sienna
- Cadmium Orange
- Cadmium Red
- Cadmium Yellow
- Cobalt Blue
- Dioxazine Violet
- Permanent Rose
- Phthalo Blue
- Phthalo Green
- Raw Sienna
- Ultramarine Blue
- Retouch White (an opaque water-based designer color) or white gouache
- ¼-inch (6mm) ½-inch (13mm) and 1-inch (25mm) flats
- Nos. 3 and 8 rounds
- 140-lb. (300gsm) cold-pressed paper
- Miscellaneous materials from page 11

Drawing Stonework
If the wall is facing you, draw the main stones using their normal shapes and fill in the spaces with smaller ones. If the wall runs away at an angle, elongate some main shapes vertically and fill in the spaces with smaller stones. Likewise, if the stonework is a roadway or floor, flatten the main shapes horizontally.

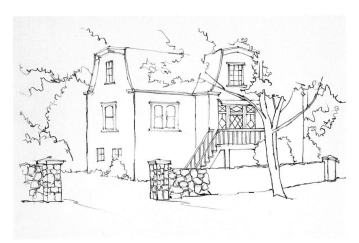

Sketch the House

1 Sketch in the stone house and the surroundings. Your composition doesn't have to be as detailed as mine. Add or delete any elements to suit your style.

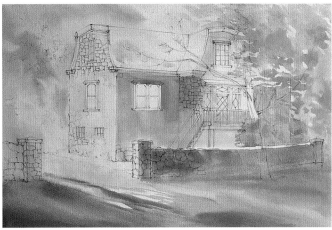

Begin Underpainting With Flat Washes

2 Wet the paper, except for the windows. Use very thin washes of Cadmium Yellow, Cadmium Orange and Cobalt Blue in the background. The shadow side of the house and rocks are done with Ultramarine Blue, Burnt Sienna and a bit of Dioxazine Violet using a 1-inch (25mm) flat. As the paper begins to dry, add a bit of Phthalo Green and Cadmium Orange to the shrubs and trees on the right.

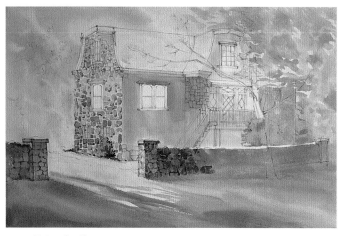

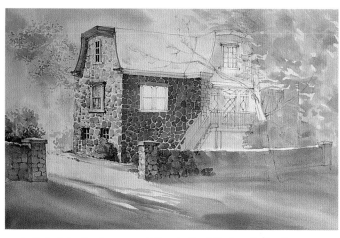

Paint the Stones

3 Make the stones in the sunlight with the no.8 round and thinned Burnt Sienna, Raw Sienna and Permanent Rose. Switch to Ultramarine Blue, Dioxazine Violet and Burnt Sienna for the shadow side.

Splash in the Leaves and Create the Window Reflections

4 Casually splash in the leaves with Cadmium Yellow, Cadmium Red and Cadmium Orange using the no. 8 round. Add a bit of Phthalo Green to the Cadmium Yellow wash on your palette for some green leaves.

Create the window reflections in the surrounding colors. The others are just Burnt Sienna and Dioxazine Violet applied with the ¼-inch (6mm) flat.

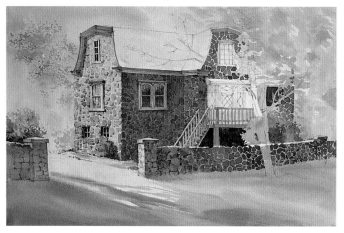

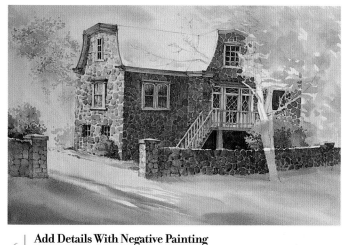

Enhance the Stones and Paint the Trim

5 Glaze the white area of the shadow with Cobalt Blue. When the stones are dry, glaze the shadow in Phthalo Blue or Dioxazine Violet using the ½-inch (13mm) flat. This will increase the dark value as well as subdue the grout. Continue even if it smears the stones, as long as your colors don't turn into mud. Paint the blue-green trim with Cobalt Blue plus a bit of Cadmium Yellow using the no. 8 round.

Add Details With Negative Painting

6 This subject calls for a lot of negative painting to complete the windows, railing and doors. Use the ¼-inch (6mm) flat for cutting in between the spindles and railing. As the dark values go in, some of the original washes appear much lighter and will have to be reglazed with their original color to correct their value.

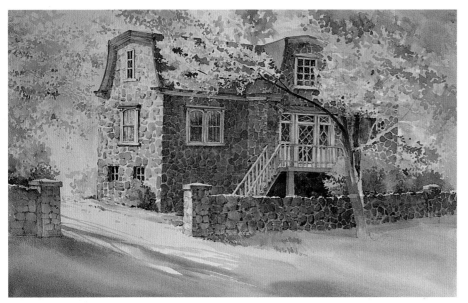

7 **Splash In the Trees**

Using the no. 8 round, add Cadmium Yellow, Cadmium Orange and Cadmium Red leaves with the occasional bit of Phthalo Green mixed with Raw Sienna to suggest that not all the leaves have turned yet. Burnt Sienna and Dioxazine Violet will make the darkest part of the tree trunk with a thinner Burnt Sienna where the sun hits. Use Cobalt Blue with a bit of Cadmium Yellow on the roof.

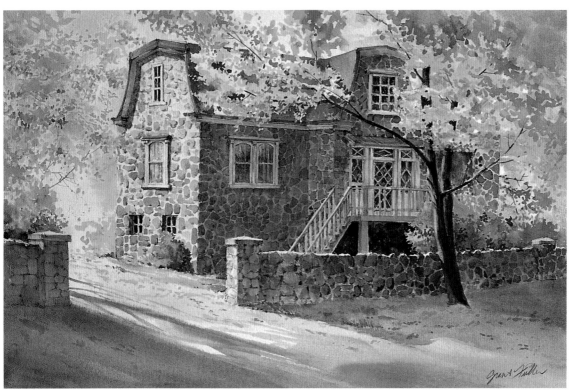

BRICK HOUSE • GRANT FULLER •
15" × 22" (38CM × 56CM)

8 **Add the Finishing Touches**

Draw in a few thin branches with the same colors you used for the tree and the no. 3 round brush. Glaze the foreground again with the 1- inch (25mm) flat to strengthen the shadows. Add spots of color here and there to represent fallen leaves.

Use Retouch White (or white gouache) in cases where very light objects are placed in front of a darker background, such as the very small leaves in front of the dark roof. You can add a few more light leaves with the retouch white—use it very sparingly. When dry, glaze with Cadmium Yellow or Cadmium Orange over the white. If handled carefully, this trick will be invisible, but if not, it will look like corrections on a badly typed letter.

TEXTURES

Watercolors are fun because they are spontaneous and unpredictable. Their consistency allows us to do creative things in landscapes to illustrate the textures around us—such as skies, seas, rocks and driftwood—that will bring the painting to life, adding creativity to your composition. Take a moment to look at some of the textures in the world around you. Using various techniques to imply the texture of something with watercolors opens a whole new, creative way to express yourself.

Moss Covered Rocks

By Mark Willenbrink

Using salt is one way to add a sense of texture to a subject—in this case, rocks overgrown with moss. Experiment on a scrap of watercolor paper to get the feel of it. The opaqueness of the pigment and how wet the paints are when the salt is applied will affect the results.

[MATERIALS LIST]

- Brown Madder
- Cadmium Orange
- Cadmium Yellow
- Hooker's Green
- Prussian Blue
- No. 14 round
- 140-lb. (300gsm) cold-pressed paper
- Kosher salt
- Miscellaneous materials from page 11

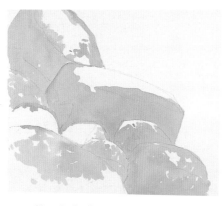

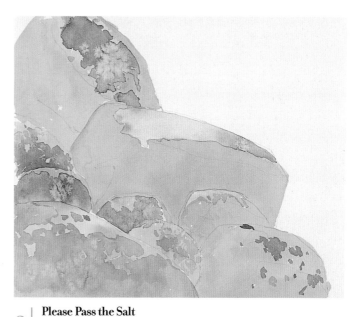

1 | Sketch the Image and Underpaint
Draw the image onto the paper with a 2B pencil. Mix Cadmium Yellow and Hooker's Green. Load your no. 14 round with the mixture and paint in where any moss grows on the rocks.

2 | Please Pass the Salt
You will be using a no. 14 round throughout the demonstration. Paint the light colors of the exposed rocks with a mixture of Prussian Blue and Brown Madder. In some places, drop Cadmium Orange into the wet paint. After applying the paint and while it is still wet, add salt for texture. Let your painting dry and remove the salt.

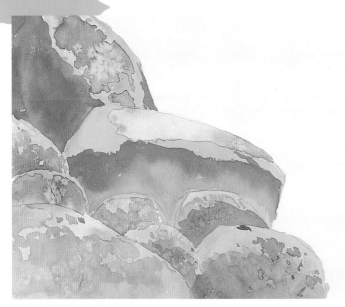

3 | **Add Mossy Green**
Add darker greens to the moss with a mixture of Cadmium Yellow and Hooker's Green. Add salt, let it dry and then remove it. Note: The salt is not as effective at this stage.

4 | **Darken the Rocks**
Add the middle darks of exposed rocks with a mixture of Prussian Blue and Brown Madder. Add salt, let it dry and then remove it.

5 | **Add the Darker Darks**
Add the dark colors to the moss with a mixture of Prussian Blue, Hooker's Green, Cadmium Orange and Brown Madder. Use the no. 14 round. Add salt. After your painting has dried, remove the salt, erase any unwanted pencil lines, sign and date your painting.

MOSSY ROCKS • MARK WILLENBRINK • 9" × 12" (23CM × 30CM)

Driftwood and Grass

By Mark Willenbrink

A sandy beach, grass and driftwood— you can almost hear the waves lapping on the shore nearby. The driftwood was once part of a living tree, but the softer fiber was dissolved away by the water and dried out by the sun. That left a bleached, tenuous remnant with the grain exposed. The grass is in clumps and somewhat angled to the left, as if it is windblown. Observe the smooth rocks that appear scattered in the sand. Your light source is coming from the right.

[MATERIALS LIST]

- Brown Madder
- Cadmium Yellow
- Prussian Blue
- Sepia
- Yellow Ochre
- Nos. 2, 8 and 14 rounds
- 140-lb. (300gsm) cold-pressed paper
- Miscellaneous materials from page 11

1 Sketch It Out
Draw the subject using a 2B pencil. Notice as you draw that the driftwood tapers in size.

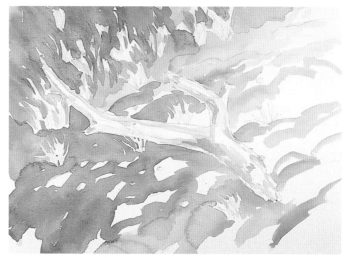

2 Paint Driftwood and Rocks
Using Sepia, Prussian Blue and a no. 14 round, paint the driftwood and rocks. (Paint the lightest elements first because it is easier to make something darker than it is to lighten it.) Painting wet-on-dry, keep the lightest areas white to emphasize the brightness. Follow the wood grain with your brushstrokes, and paint around any grass that overlaps the wood.

Paint the sand wet-on-dry using a no. 14 round and a combination of Yellow Ochre, Brown Madder and Sepia. Work around the rocks, grass and the light areas of the sand in the foreground. While it's still wet, drop in some green—mixed from Yellow Ochre and Prussian Blue—into the background.

3 Paint the Grass and Shadows
Paint the grass with a no. 8 round using a green mixture—Yellow Ochre, Prussian Blue, Cadmium Yellow and Brown Madder—making thick and thin strokes.

Paint in shadows and add form to the driftwood with a mixture of Yellow Ochre, Brown Madder and Prussian Blue using a no. 8 round.

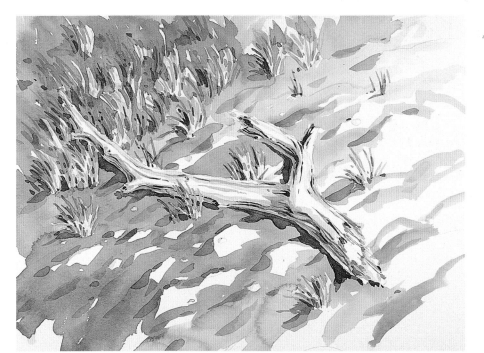

4 | **Add Shadows to the Sand**
Create a mixture of Yellow Ochre, Brown Madder and Prussian Blue, add shadows and indentations to the sand using a no. 14 round. Follow the existing light and dark patterns. It may make it easier to paint these small hills if you think of them as waves on an ocean.

Add the dark details to the grass using a no. 8 round with a mixture of Yellow Ochre and Prussian Blue.

Detail the dark areas of the wood with a no. 2 round using Brown Madder, Prussian Blue and Sepia.

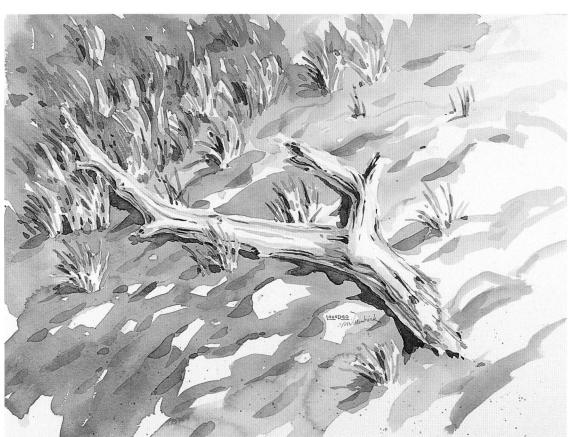

5 | **Add Final Details With Splattering**
Imply texture to the sand by splattering a mixture of Brown Madder, Prussian Blue and Yellow Ochre. Before you start, cover up any areas you don't want splattered. One easy way to splatter paint is to whack a no. 14 round loaded with paint against the handle of another brush. When you are satisfied with your painting and it is dry, erase your pencil lines, sign and date your painting.

DRIFTWOOD AT IROQUOIS POINT • MARK WILLENBRINK • 10" × 14" (25CM × 36CM)

Desert Landscape

By Mark Willenbrink

What interests me about this picture are the contrasts, specifically the contrast of light and darks, but also the contrasts of warm and cool colors. The grass is a also a contrast to everything else because it's the only living element in the scene.

[MATERIALS LIST]

- Brown Madder
- Cadmium Orange
- Hooker's Green
- Prussian Blue
- 2-inch (51mm) flat
- Nos. 8, 10 and 14 rounds
- 140-lb. (300gsm) cold-pressed paper
- Miscellaneous materials from page 11

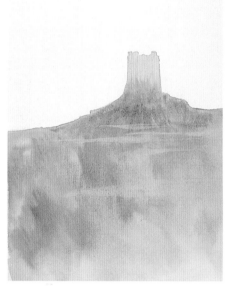

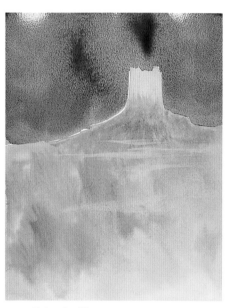

1 | **Paint in the Rock and Foreground**
The light source is coming from the left. This will be important to know in the later steps when shadows will be painted. Draw the image onto the paper with a 2B pencil. Mix up lots of Cadmium Orange and water on your palette and, working quickly, paint a flat wash of the Cadmium Orange mixture with a 2-inch (51mm) flat.

2 | **Distinguish the Rocks and Grass**
Drop Brown Madder, Prussian Blue and Hooker's Green mixed with Cadmium Orange into the wet area using the no. 14 round. Tilt the painting to manipulate the wet colors. Clean your brush and load it with clear water. Apply this to the almost-dry paint. Use horizontal strokes to brush away the former paint, leaving streaks. Let dry.

3 | **Paint the Sky**
Using the 2-inch (51mm) flat, wet down the sky area with Prussian Blue mixed with small amounts of Brown Madder and a mixture of Cadmium Orange and Prussian Blue.

Add Clouds to the Sky

4 | With the no. 14 round, drop clear water into the sky just before the initial sky wash dries. This should push away some of the original blue pigment to create cloud effects. Tilt your painting sideways to create more horizontal cloud shapes. Note: Some papers will be more responsive to this technique than others.

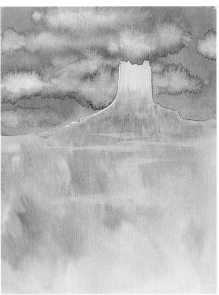

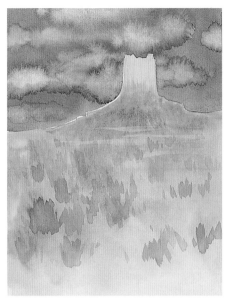

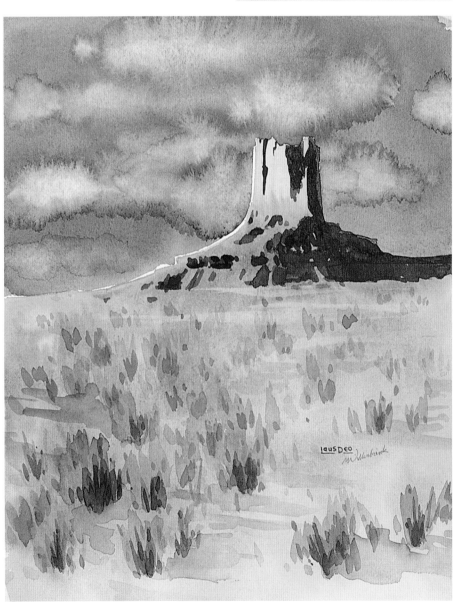

Add Details

5 | Add details to the grass and shrubs in the foreground by painting with a no. 14 round loaded with Cadmium Yellow, Prussian Blue, Hooker's Green and Brown Madder. Notice: the closer they are to the viewer, the taller they are.

Add Shadows

6 | Add shadows to the foreground grasses, shrubs and rock formations with nos. 8 and 10 rounds. Once again, use Cadmium Yellow, Prussian Blue, Hooker's Green and Brown Madder. Once your painting is dry, erase your pencil lines, sign and date your painting.

DESERT CONTRASTS • MARK WILLENBRINK • 12" × 9" (30CM × 23CM)

Slick Rocks

By Mark Willenbrink

When comparing wet rocks to dry rocks, wet rocks are darker, more colorful and have sharply defined highlights. Dry rocks are lighter in value, paler blue-gray and have more gradual highlights.

These rocks are wet from the tide coming and going. Being wet, they look glossy, having places on them where the sunlight is reflected as a highlight. It's important to include the highlights in your initial drawing, so that you remember to leave them the white of the paper while you're painting.

[MATERIALS LIST]

- Alizarin Crimson
- Brown Madder
- Cadmium Orange
- Cerulean Blue
- Prussian Blue
- Quinacridone Purple
- Yellow Ochre
- No. 6 mop quill (or a no. 18 round)
- Nos. 8 and 14 rounds
- 140-lb. (300gsm) cold-pressed paper
- Coarse kosher salt
- Miscellaneous materials from page 11

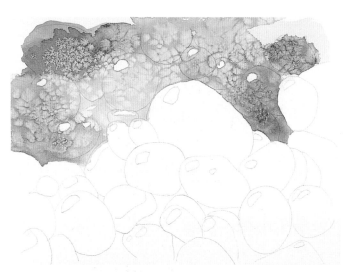

1 | Paint the Rocks Loosely and Add Salt For Texture

Wet down the paper with a no. 6 mop quill and drop in a mixture of Alizarin Crimson, Cadmium Orange, Quinacridone Purple, Cerulean Blue, Yellow Ochre and Brown Madder using a no. 14 round. Paint the rocks loose and wet, letting the colors bleed from one rock to another, except where you want the highlighted areas to remain white. Add salt for texture while the paint is wet. To make it less overwhelming, paint a portion at a time. When the painting is completely dry, carefully wipe off all the remaining salt. The Quinacridone Purple area had lots of salt sprinkled on a relatively dry surface. The Yellow Ochre area, toward the center, was wetter, with less salt.

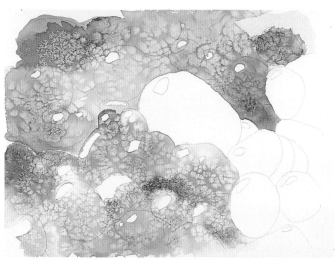

2 | Repeat Step One

Repeat step one until you have completed all the base colors of the rocks. Work slowly and in small areas.

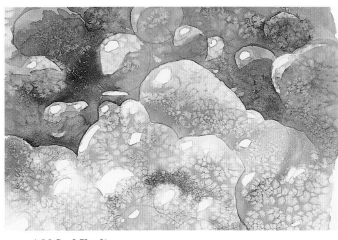 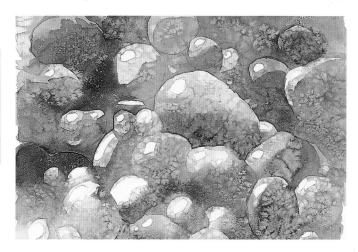

Add Cool Shading

3 With a no. 14 round brush, shade the rocks with darker versions of the base color. This will add depth to the rocks. Because the light source is coming from the upper left, the round rocks will be darkest to their lower right. Keep individual rocks similar in color as originally painted, but paint darker in color. Add salt if the texture seems to be getting lost with the additional washes of paint. Let dry and remove the salt before proceeding. Gradually continue to build the shaded areas.

Define the Rocks With Dark Values

4 Detail the dark areas with Prussian Blue and Brown Madder using the nos. 8 and 14 rounds. Randomly add salt to some of the stones, wiping them off after the paint has dried.

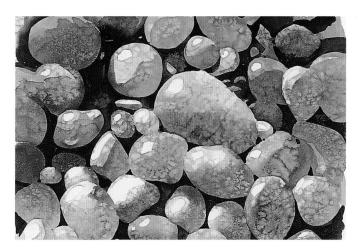

Add More Cool Shading

5 Add more shading to the rocks. Continue to build the shaded rock areas With a no. 14 round. Erase any unwanted pencil lines, sign and date your painting.

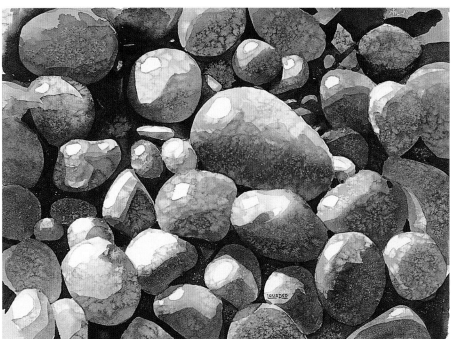

WATERSTONES • MARK WILLENBRINK • 9" × 12" (23CM × 30CM)

Wooden Sawhorse

By Jack Reid

This is another exercise in painting wood texture. The old wooden sawhorse in the grass is a simple shape, yet it has a lot of character. You will notice the color of the grass is not like it is in the photo. Instead, a strong sense of sunlight was implied. To indicate strong light, it is also important to paint strong, contrasting shadows. Look carefully at the finished painting and you will get a sense of the strength the shadows require.

[MATERIALS LIST]

⑥ Aureolin Yellow

⑥ Burnt Sienna

⑥ Cobalt Blue

⑥ Ultramarine Blue

⑥ Viridian

⑥ ½-inch (13mm) and 1-inch (25mm) flats

⑥ No. 8 round

⑥ 300-lb. (640gsm) rough watercolor paper

⑥ Miscellaneous materials from page 11

1 | Sketch It Out
Sketch in the sawhorse as shown.

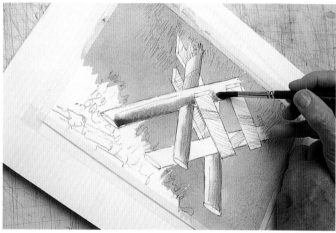

2 | Wash in the Grass and Begin the Sawhorse
Mix Viridian, Burnt Sienna and Aureolin Yellow into a yellowish green. Using a 1-inch (25mm) flat, paint a flat wash around the sawhorse. While it's still wet, score the wash with a utility knife to indicate blades of grass. Allow to dry.

Mix a medium brown wash with Cobalt Blue and Burnt Sienna. Turn your paper upside down. With a no. 8 round, paint four graded washes along the edges of the sawhorse. Remember to start with clear water; then paint a flat wash across the boards. The color should gradually darken as you progress down. Let dry.

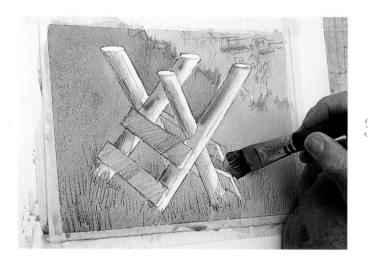

3 | Create Depth and Brighten the Grass
Drop pure Burnt Sienna into the rounded portions of the sawhorse. Lighten the wash; then using a ½-inch (13mm) flat, glaze over the flat boards. Allow to dry.

If you find the grass area looks dead against the sawhorse, liven it up with a vibrant yellowish green wash of Viridian, Burnt Sienna and Aureolin. Using a 1-inch (25mm) flat, glaze over the entire grass area. Allow to dry.

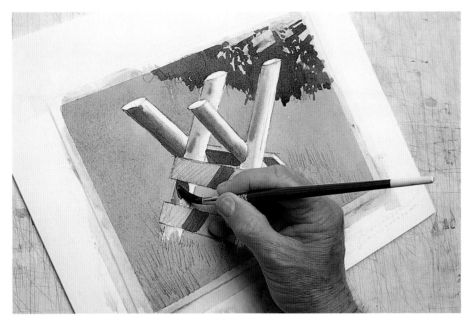

Paint the Shadows

4 | In this step you'll create distinct shadows to make the sawhorse stand out. Mix a medium brown wash from Burnt Sienna and Ultramarine Blue. Paint the woodpile with a no. 8 round; then paint dark shadows on the sawhorse. Notice how powerful the picture has become by virtue of the shadows, particularly on the woodpile.

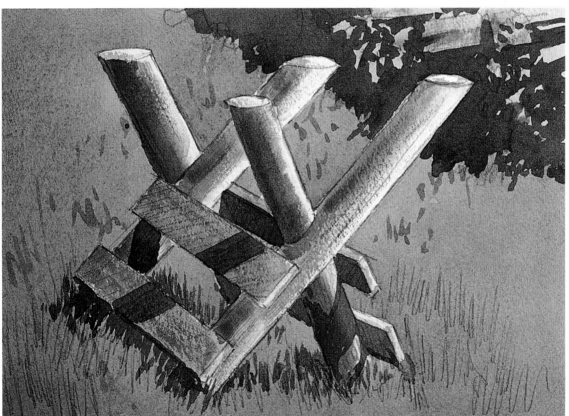

Add Finishing Touches

5 | With the same wash and brush, paint additional shadows on the round portions. To complete the picture, using the same wash and a ½-inch (13mm) flat, drybrush over the boards to indicate wood texture.

WOODEN SAWHORSE • JACK REID • 7½" × 10" (19CM × 25CM)

Contributors

Brigitte Schreyer was born, raised and educated in Germany. She emigrated to Canada, settling in Winnipeg, Manitoba. Always having a special love of the fine arts (her father was a talented landscape painter), Brigitte began painting seriously after moving to Ontario in 1972.

She studied a variety of painting media with various accomplished Canadian and American artists. Brigitte has been teaching since 1978 and currently conducts watercolor workshops at her studio, specializing in her glazing techniques.

Brigitte is an elected member of many art and watercolor societies. She has had numerous solo and group exhibitions. Her work is in many corporate and private collections throughout North America and Europe.

Linda Kemp is the author of *Watercolor Painting Outside the Lines* (North Light, 2003). A full-time artist, she frequently instructs and lectures at national symposiums and watercolor workshops throughout Canada, the United States and the United Kingdom. Her paintings and articles have been featured in many publications including *American Artist, International Artist* and *The Watercolor Gazette*.

Linda is an elected member of many art and watercolor societies. Her award winning paintings are in private, public and corporate collections around the world, including The Royal Collection, Windsor Castle, U.K. Linda's home and studio are nestled on the Niagara Escarpment in southern Ontario, Canada. You will find her work at www.lindkemp.com.

Mark Willenbrink was trained as a commercial artist and worked in advertising and then as a freelance illustrator. Mark currently teaches classes and is a contributing editor for *Watercolor Magic*. **Mary Willenbrink** obtained a master's degree in counseling and worked as a drug and alcohol counselor. Besides her work as a writer, she currently homeschools their two children.

As a husband-and-wife team, Mark and Mary have been writing together for over five years. They reside in Cincinnati, Ohio, with their two children, one cat and a rescued greyhound.

Canadian Artist **Grant Fuller** was born in Winnipeg and first showed a fascination with drawing at the early age of four. He graduated from the Vancouver School of Art and began his career as a commercial artist in Toronto.

Grant worked as an art director, advertising manager and broadcast production manager for Sears Fashion. He and his lovely wife, Myrna, later moved back to Victoria where Grant began painting full time.

Grant's paintings have won several awards and have been featured in national magazines and newspapers. He teaches watercolor workshops and courses. You can find his work at www.grantfuller.ca.

Index

The best in watercolor instruction and inspiration is from North Light Books

Begin your watercolor journey by mastering the basics with Mark and Mary Willenbrink. This highly visual guide will lead you through demonstrations on proper brush technique and planning a painting while focusing on fundamental topics such as materials, value, color and composition. Fifteen easy-to-follow projects will spark your creative expedition with watercolors.

ISBN 1-58180-341-9, paperback, 128 pages, #32310-K

No matter how little free time you have to paint, this book gives you the confidence and skill you need to make the most of every second. You'll learn a variety of timesaving techniques then begin creating simple finished paintings within sixty minutes. Twelve step-by-step demos make learning easy and fun.

ISBN 1-58180-035-5, paperback, 128 pages, #31800-K

Dory Kanter's inspirational guidance is perfect for both beginning and experienced artists alike. *Art Escapes* gives readers a fun, easy-to-execute plan for building an "art habit." Inside, you'll find daily projects for drawing, watercolor, mixed media, collage and more. With Art Escapes, you'll experience heightened artistic skill and creativity, and find the time to make a little bit of art everyday.

ISBN 1-58180-307-9, pob w/concealed wire-o, 128 pages, #32243-K

Create alluring works of art through negative painting—working with the areas around the focal point of a composition. Through step-by-step techniques, exercises and projects, you'll learn to harness the power of negative space. Linda Kemp's straightforward diagrams for color and design as well as troubleshooting suggestions and secrets will make your next watercolor your most striking work yet!

ISBN 1-58180-376-1, hardcover, 128 pages, #32390-K